AWKWARD FAMILY PHOTOS

AWKWARD
FAMILY
PHOTOS

MIKE BENDER &
DOUG CHERNACK

HODDER &
STOUGHTON

First published in the USA by Three Rivers Press in 2010
First published in Great Britain in 2010 by Hodder & Stoughton
An Hachette UK company

7

A CIP catalogue record for this title is available from the British Library

Hardback ISBN 978 1444 70426 6
Trade paperback ISBN 978 1444 70531 7

Printed and bound in Italy by Lego SpA.

Hodder & Stoughton policy is to use papers that are natural, renewable
and recyclable products and made from wood grown in sustainable forests.
The logging and manufacturing processes are expected to conform to the
environmental regulations of the country of origin.

Hodder & Stoughton Ltd
338 Euston Road
London NW1 3BH
www.hodder.co.uk

This book is dedicated to our own awkward families

Contents

Introduction

Family. They're the people we love, the people we trust and confide in, the people we identify with. But there's something else about family that isn't often spoken about, because, well, it's not always comfortable to admit. So, let's just put it out there—*family is awkward.* That's right. When a group of people with the same name and different personalities are forced to spend most of their lives together, plenty of uncomfortable moments are sure to follow. And when a camera is there to capture one of those moments, an awkward family photo is born.

So, we set out to create a friendly place where people could suffer together and feel comfortable sharing their own odd family moments. We launched AwkwardFamilyPhotos.com in April 2009 with a handful of pics gathered from our families and friends. A friend who worked for a radio station in Providence, Rhode Island, offered to post our link on the station's website. We thought we would get only a few hits, but when the link was picked up by radio stations all over the country, photographs of families straddling trees and piled on top of one another flooded in, with comments like "Thank you for showing me that my family isn't the only one!" and "Oh, you think your family is awkward???" They were sent to us from teens, mothers, fathers, and grandparents. And they didn't just come from the United States. There were submissions from Australia, England, Norway, Brazil, the Czech Republic, China,

and all over the world. It quickly became clear to us that the awkward family was a universal phenomenon.

This book features popular photos and stories from the site, and also many never-before-seen ones. Ultimately, though, it is about much more than just photos and stories. It's about celebrating the family experience and shining a light on all of those deliciously awkward moments that come with the price of membership: the road-trip sing-along, the meeting of the in-laws, having to take a cousin to the school dance.

There has been much debate on the website as to what constitutes a family photo. For us, it has always included everything from the classics (portraits, holidays, vacations, weddings, etc.) to those random pictures we probably have stuffed in a drawer or packed into shoeboxes in the attic (old school photos, family pet pictures, even the solo shot Mom made us take with our viola). As far as a perfect definition of awkwardness, we don't know that it exists. Everyone can look at a picture and take away something different about what makes it awkward, but as long as the viewer feels some level of discomfort, there is awkwardness.

We want to acknowledge and thank the people who have made the awkwardness possible—the amazing families who so generously shared their photos with us. You let us into your homes and you did it with a sense of humor. Through your pictures, we see our own families and can take comfort that we're in good company. It is our hope that this book will bring all our families a little closer together as we acknowledge those special times when we wished we were a lot farther apart.

Awkwardly,
Mike Bender and Doug Chernack
www.AwkwardFamilyPhotos.com

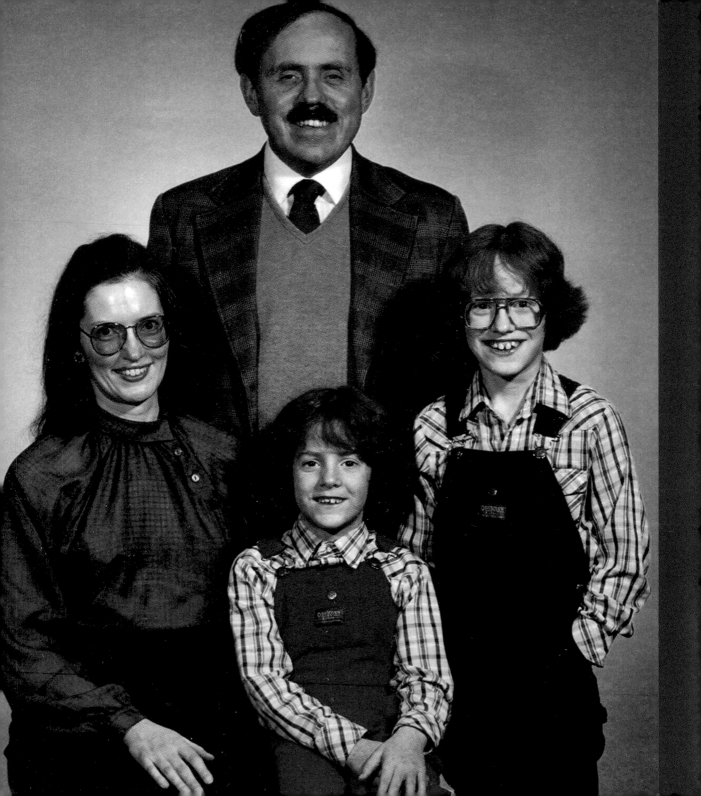

1

The Family Portrait

Walk into just about anyone's home and you can find one hanging prominently on the wall proudly displayed for all to see. An attempt at wish fulfillment for Mom and Dad, the family portrait provides the chance for them to capture the ideal vision of their brood—ridiculously happy, clean-cut, well-dressed, and not trying to kill one another. For some of us, the image was created in a mall studio where a "professional" photographer arranged us by height, tilted our heads, placed our hands on our siblings' shoulders, and reminded us to keep smiling despite the blinding lights in our faces and the dreary backdrop behind us. Others opted for the old self-timer technique, which left us frozen in the same position for over an hour while Dad tried to make the damn thing work.

But if we look past the matching sweaters and the choreographed poses, we will often see a more interesting story—the true family dynamic, complete with quirks and vulnerabilities. Perhaps not the ideal family Mom and Dad were hoping to spotlight, but the results are often the most honest snapshots of all.

# A TOUCH OF WICKER

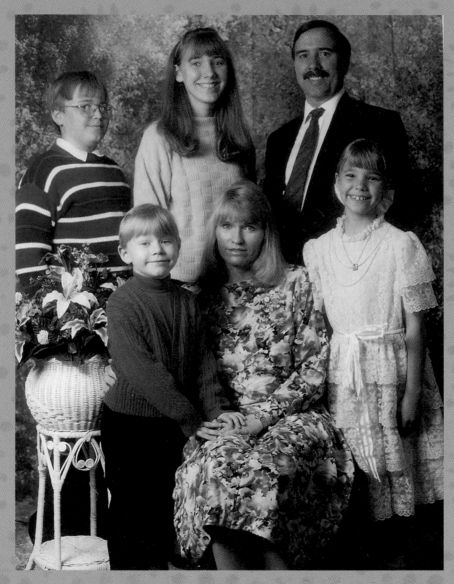

The photographer felt that adding a fake plant would make this portrait look more natural.

THE HOMESTEAD

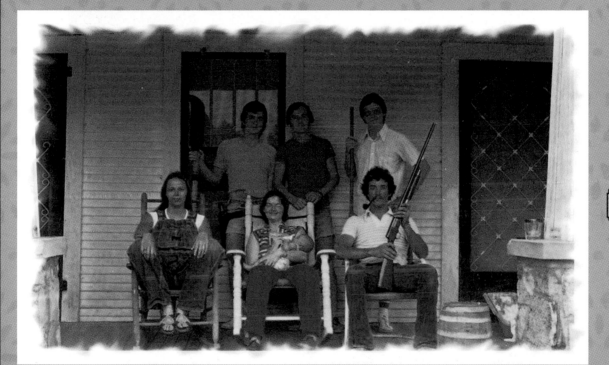

This family sends a mixed message of "Welcome to our home" and "Stay the hell off our property."

14

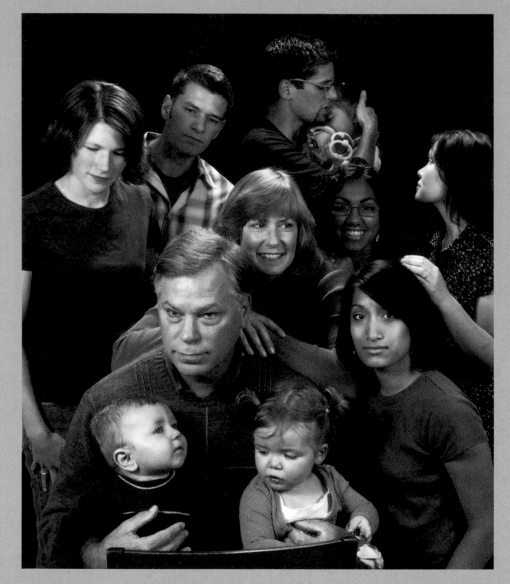

Choose your own adventure.

HOME OFFICE

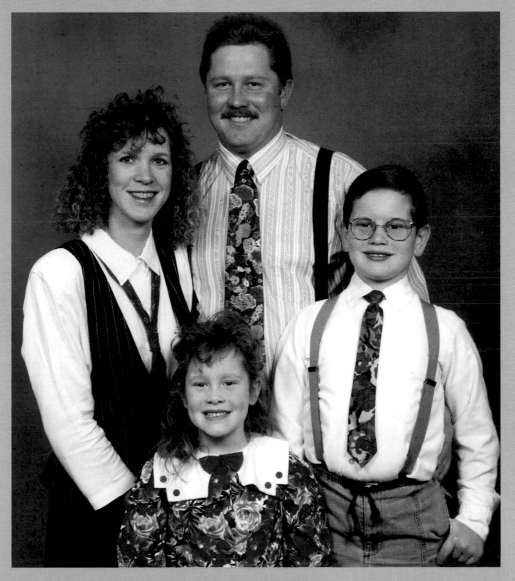

Immediately following the portrait session, everyone in this family headed out for a job interview.

PUNKS IN SPACE

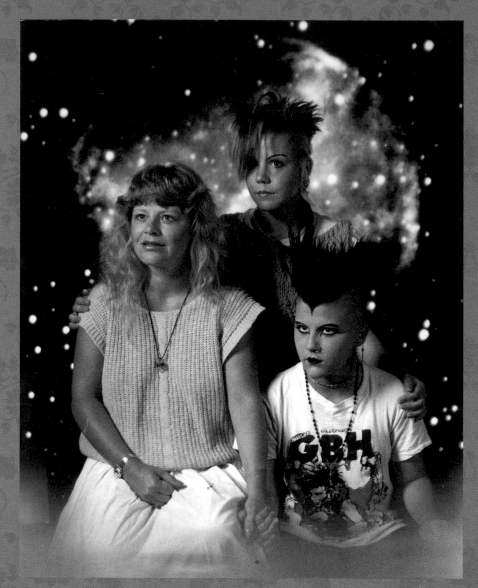

Generational differences can be put aside in a galaxy far, far away.

THERE'S PLENTY OF ROOM
ON THE COUCH

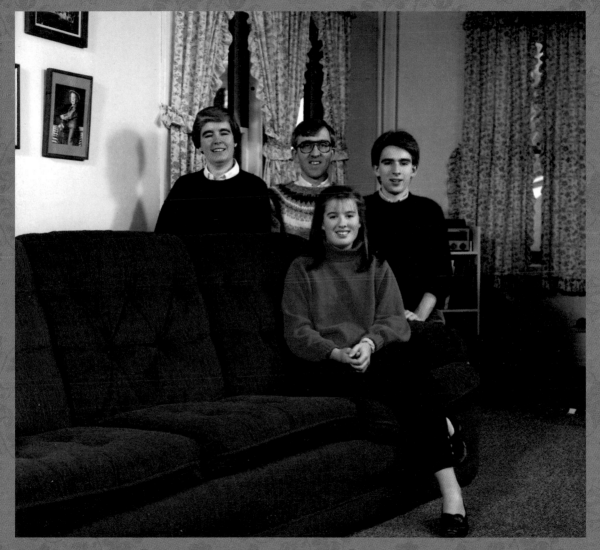

But the chairs are all taken.

BEHIND THE
AWKWARDNESS

This is the first photo we took
after moving to Humble, Texas,
from Chicago in 1981. My dad's
intention was that we should
look the part. You be the judge.

The Bychowski Family
Humble, Texas

My parents always wanted a
boy, so they forced us to show
our manly side with these
homemade ties.

The Perry Family
Redmond, Washington

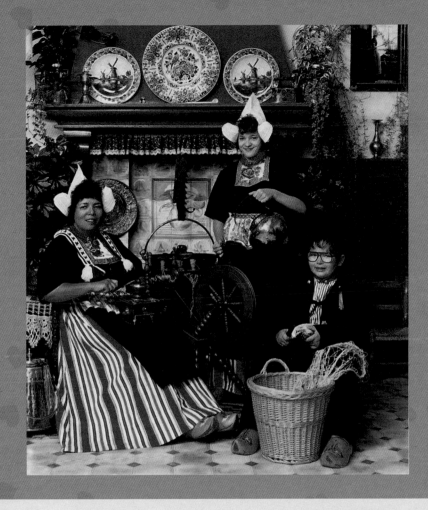

We went to Holland, where my mother is from, and had this picture taken. The thing that strikes me most is the fact that we are doing several activities awkwardly close to each other that are not particularly compatible—spinning wool, pouring hot water, and cleaning fish? Oh, and did I mention the wooden shoes?

The Kleinman Family
Mountlake Terrace, Washington

THE SPACE BETWEEN

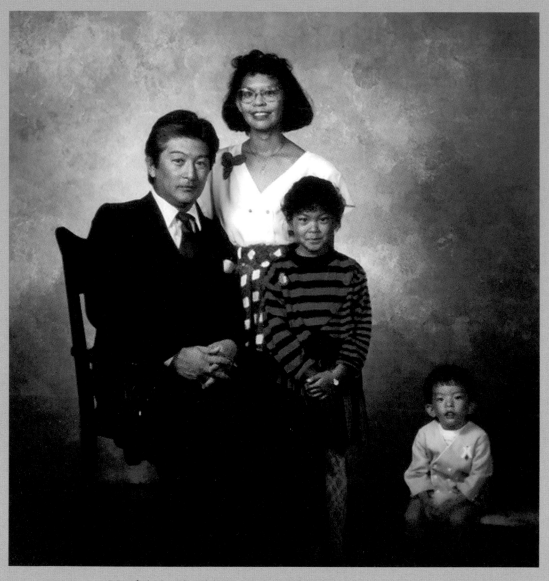

He felt he had been carrying them for too long.

ALL MY CHILDREN

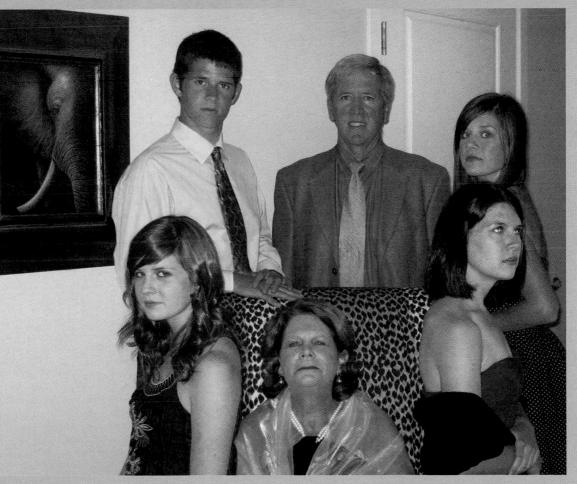

You know there's drama in the family when there is literally an elephant in the room.

CONFESSIONS OF A PORTRAIT PHOTOGRAPHER

For all the families who came to my portrait studio, I have a confession to make. I know that I told you forty-five degree head turns and hands on shoulders were good ideas, but as you're probably well aware now, that kind of wasn't true.

Here's the story. When I took the job, the company made all of the photographers go through this old-school training program that probably hadn't been updated since the fifties. They told us that these "popular" poses were the best sellers and that it was our job to sell them. So, when you asked us, "Does this look good to you?" and I told you with a straight face, "It's good enough to be in a magazine!", what I really should have said was, "Maybe in 1953." For that, I'm sorry, and although you might never have made it into that magazine, I can say that your family portrait is probably good enough to make it into this book.

Salvatore Sebergandio
Professional Portrait Photographer, (1993–1995)

THE LOOKOUT

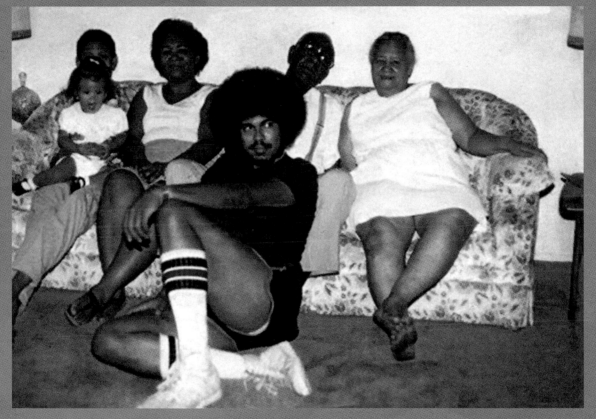

Mind the fro.

DUST STORM

Imagine growing up and never even knowing what a crumb looks like.

CLOSE FAMILY

This baby has just experienced its first invasion of personal space.

AWKWARD FAMILY POSES

The Armshelf

The '69 Mustang, Aviator sunglasses, the Armshelf. Need we say more? This classic pose simply and elegantly states, "I'm carefree, playful, and badass enough to support the weight of my own head when lying on my side in a horizontal position." If that's the vibe you're going for, then the A-shelf is one weapon you should consider adding to your arsenal.

The Lean

Warning: This pose isn't for the conservative family. It's for the clan with sass, one that wants to convey, "Heads up," "Coming at ya," "In your face," "Take a closer look," and, of course, "You rang?" Combine with two arm-fold bookends and you've got yourselves an album scorcher.

The Pile-On
For that tight-knit group who are so close, they are literally on top of one another. For maximum comfort, go denim.

The Oh-What-a-Feeling
If you get the urge to jump for joy at your next family reunion, then reach for the sky with this overly enthusiastic fan favorite. Fully extended arms won't get you any higher, but they will distract others from noticing there's only an inch between you and the ground.

MY TWO DADS

If only there was some way to tell who is who . . .

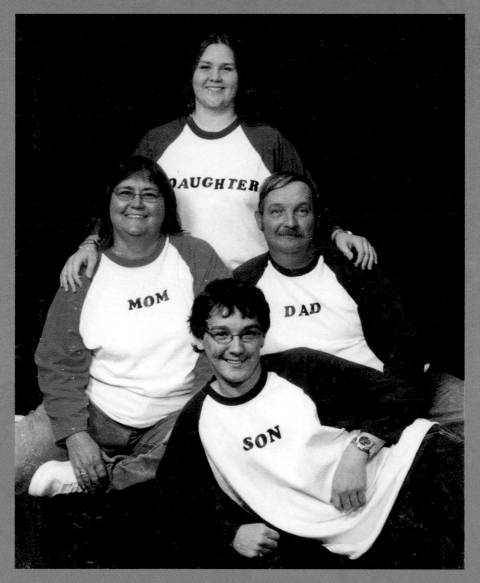

. . . Ah, that's more like it.

MATCHY-MATCHY

Even though they share the same last name, physical features, and chromosomal makeup, some families feel the need to present even more evidence that they're related. What better way to do that than through the unifying power of matching clothing?

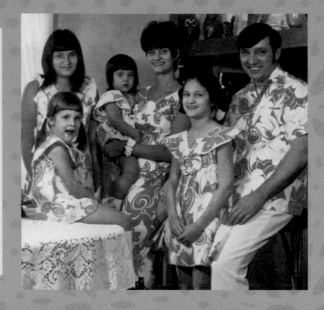

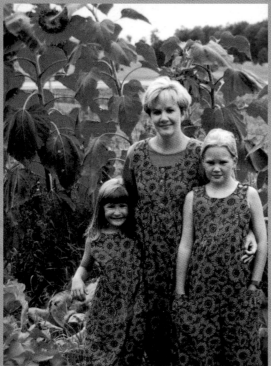

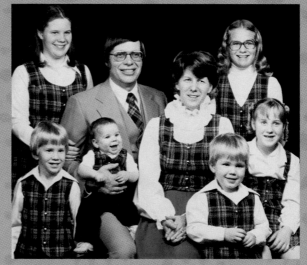

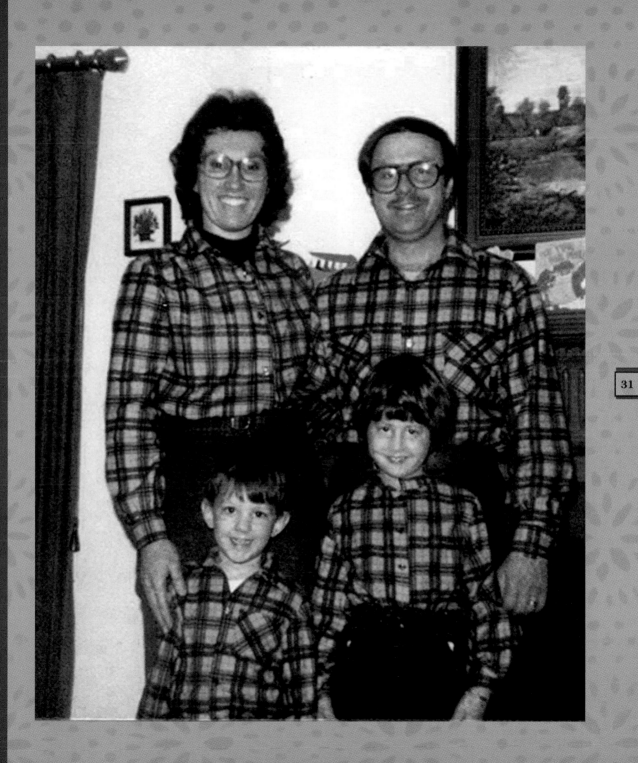

PICTURE PERFECT

For Mom and Dad, taking the family portrait is serious business. After all, this is their chance to show everyone at work how perfect their kids are. So, when things go awry, they are there to keep the progeny in line. Sort of.

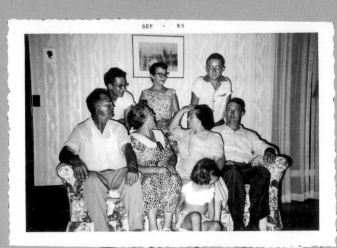

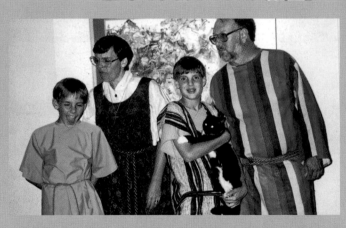

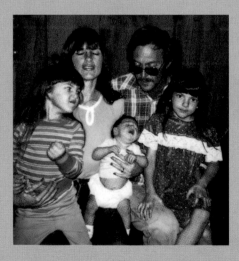

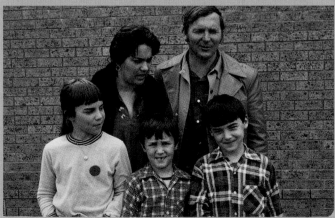

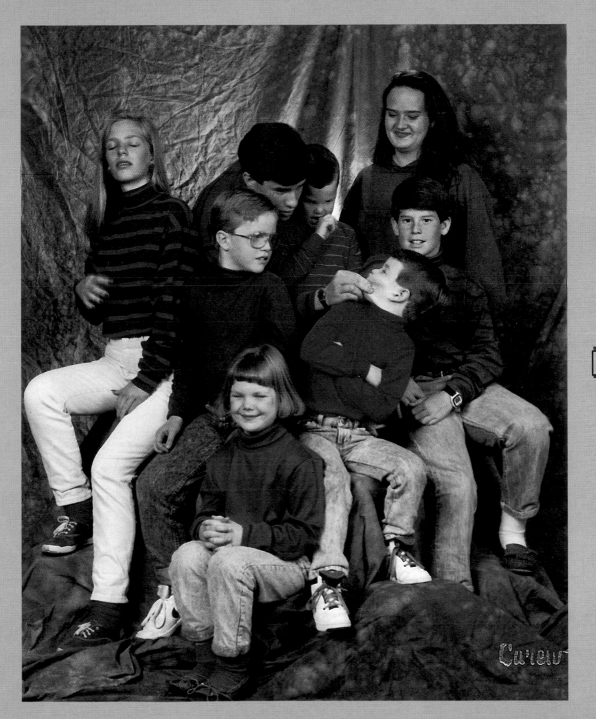

2

Mom and Dad

No matter how old we are, our parents always seem like the most awkward people who have ever lived. Dad is famous for his Hawaiian shirts, taking naps at the movies, and singing along to the easy listening station while we're in the backseat with our friends. Mom is known for her perms, constantly mispronouncing people's names, and insisting on coming into the party to pick us up. And no matter how many times we roll our eyes and ask them to please not be so embarrassing, they continue to make it their mission to humiliate us on a daily basis.

Truth is, that embarrassment is a small price to pay for having two people who will always be there for us. Still, it wouldn't hurt to lower the pants a few inches, lose the fanny packs, and stop picking up the phone when we're already on the line.

A FATHER'S LOVE

Who says fathers and sons have trouble showing affection?

MOTHER KNOWS BEST

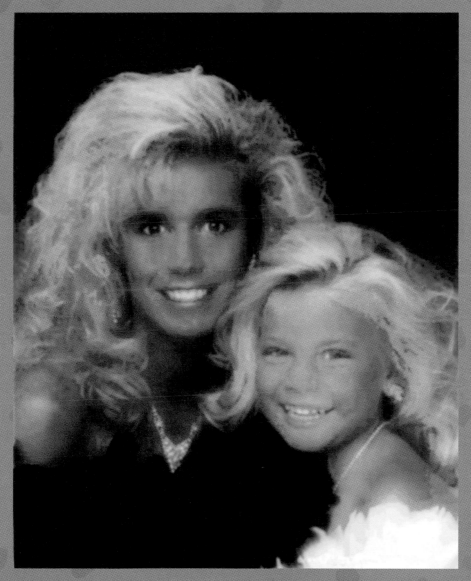

Mom will support you no matter what you decide to do in life as long as it's exactly what she tells you.

HANGIN' TOUGH

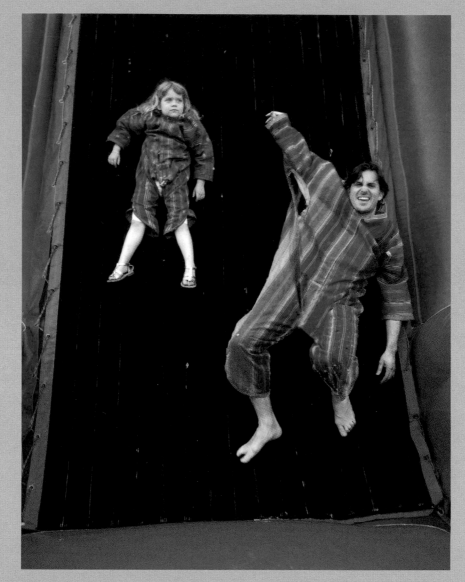

Yes, this is the man that will be guiding you through the
most important decisions of your life.

COPYCATS

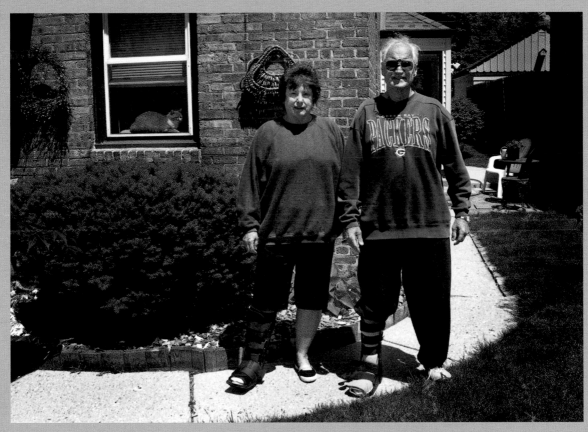

Lately, Mom and Dad have been doing everything together.

AWKWARD MOM
AND DAD STORIES

One summer when I was sixteen, I was hanging out with my dad (he worked from home for a few years). One day my mom called just to check in. I picked up the phone to say "Hi" to my mom. Seconds later my dad picked up, not knowing that I had as well. He propositioned my mother for a "quickie." My mother hesitated and then said, "Son, are you still on the phone?"

Jeff
Little Rock, Arkansas

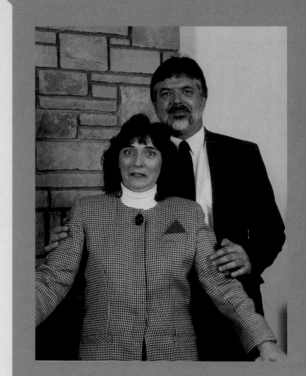

I was a big Yankees fan growing up, and when my dad bought tickets to take me to my first game, I was so excited. I couldn't wait to go to Yankee Stadium, eat a hot dog, and maybe catch a foul ball (I, of course, brought a mitt just in case). In the fifth inning, I couldn't believe it when a foul ball was actually headed our way. I stood up, raised my glove into the air . . . and was knocked to the ground by another fan, who jumped on top of me to catch it. The other fan was my dad.

Doug
Bernardsville, New Jersey

I recently brought several loads of laundry to my parents' house to do while they were out of town. Today, I received the following e-mail from my dad:

Found what appears to be black ladies'
underdrawers (maybe a G-string) in the family
room and Tom claims they're not his. Any ideas?
Love, Dad

Vanessa
New York, New York

When I was fifteen, my dad took us on a family cruise to the Caribbean. To save money, we all shared a stateroom. My dad snores at night, and after a few days of no sleep I decided to shove my bedding in the tub and sleep there. Around 5 A.M. I woke up to my dad making sounds on the toilet. I was afraid I'd give him a heart attack if I said something, so I remained quiet behind the curtain for a hellacious grunt-filled forty-five minutes.

Anna
Bentonville, Arkansas

Mom and I went on vacation in Hawaii and when we checked into the room, I watched in amazement as she unpacked a blender from her suitcase. She planned on making her own smoothies because they're so expensive at hotels and because, she said, the fruit is fresh in Hawaii. And the best part was that every time she blended one up, she would remind me how much she'd saved us. In the end, I believe the grand total came to $8.75.

SuChin
New York, New York

THE KISS OFF

He's wondering if they come with a gift receipt.

FOR BETTER OR FOR WORSE

This mother and daughter vow to love, honor, and cherish driving each other crazy.

HAPPY DAYS

Sit on it, Dad.

PIN THE TAIL

Clearly, Mom and Dad's love for each other is infectious . . .

SAFE AND SOUND

We can always take comfort in knowing that on Mom and Dad's watch, we'll never be put in harm's way.

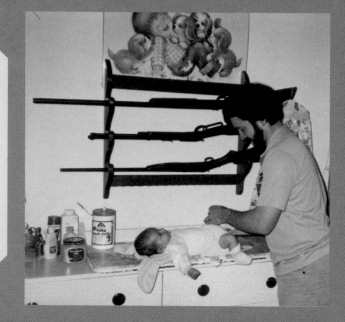

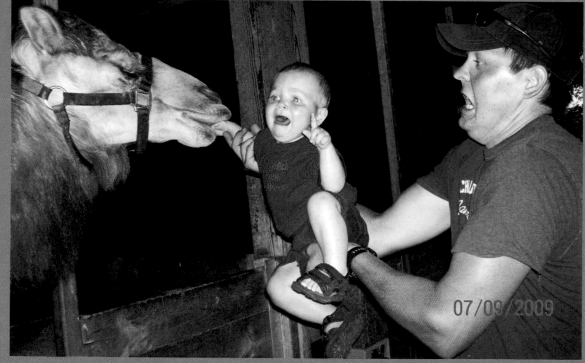

07/09/2009

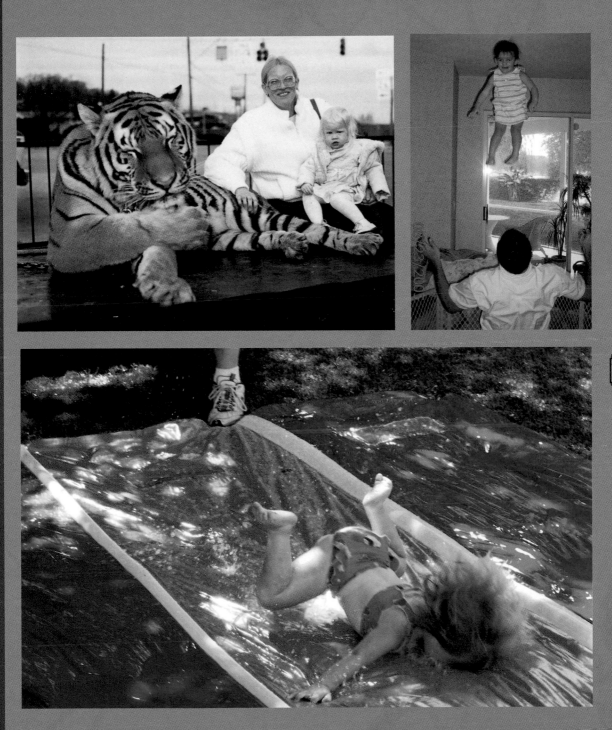

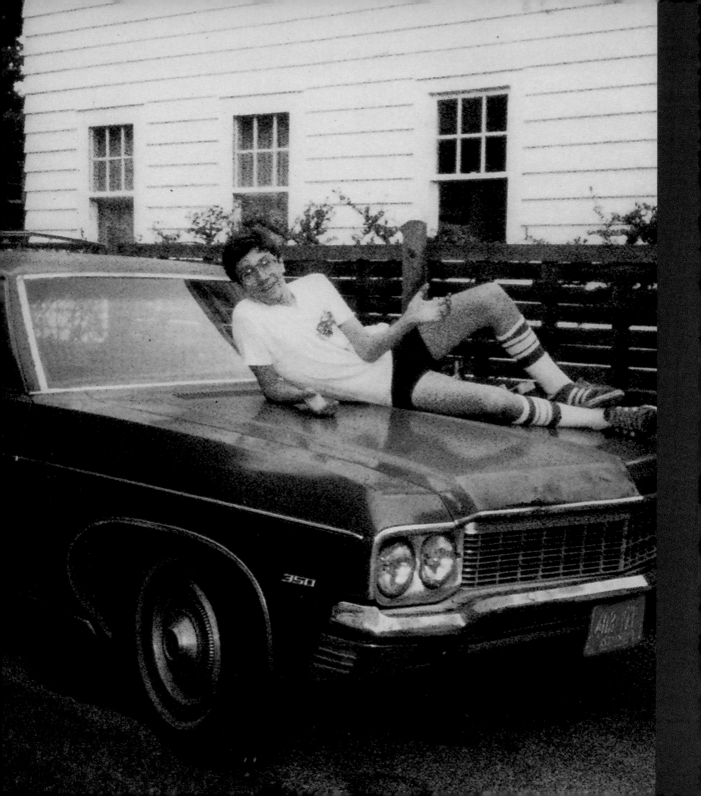

3

The Kids

When we look back at pictures of our childhood, it's obvious that being a kid was one extended period of awkwardness. We can be excused for our appearance in our first few years; however, once we hit the double digits, we had to share in some of the blame. After all, we parted our own feathered hair down the middle, sported those Velcro sneakers with zipper pockets, and proudly wore mesh shirts. And that was just the tween years, only a warm-up to the turbulent storm of teendom, when certain parts of our bodies grew while others lagged behind; our voices cracked; we started wearing a bra; and our faces erupted. We were forced to don awkward accessories: thick-rimmed glasses, braces, or—worst case scenario—headgear. We discovered the opposite sex, but for all the reasons listed above, the opposite sex didn't discover us. It seemed like we were dealing with a potentially life-threatening crisis every day.

Luckily, we don't have to rely on just our memories to help us recall all of these painful moments, because our parents were taking pictures every step of the way.

BORN TO BE AWKWARD

For anyone who doubts that an awkwardness gene exists, we'd like to present the following scientific evidence . . .

THE BIRD

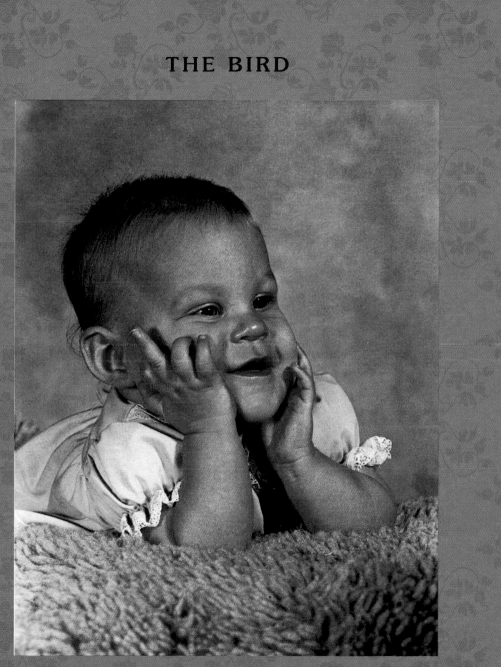

The great thing about kids is that they tell us exactly what they're thinking.

FAST HANDS

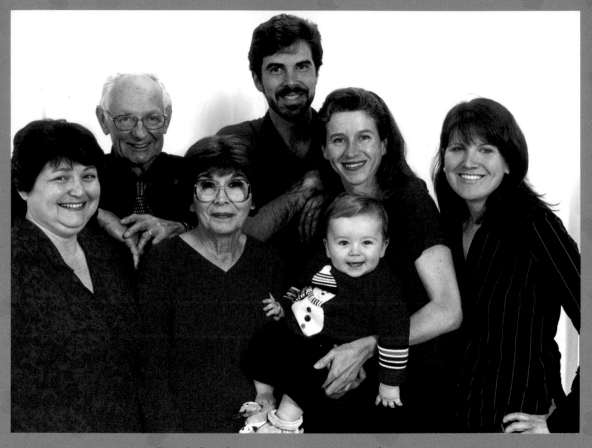

Don't let the snowman sweater fool you.

SLEEPING BEAUTY

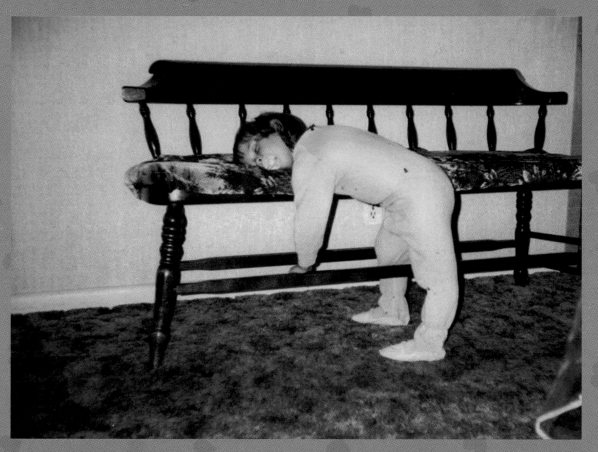

She needed to take a quick power nap before her nap.

WELCOME TO THE DOLLHOUSE

Cute, cuddly, occasionally terrifying. For the kids, dolls are like members of the family, so AFP honors these tiny lifelike inanimates for making it all right to talk to ourselves.

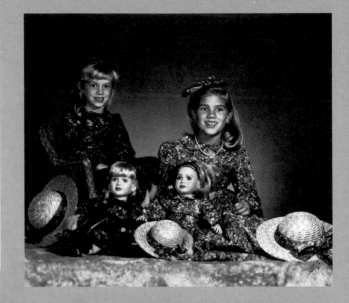

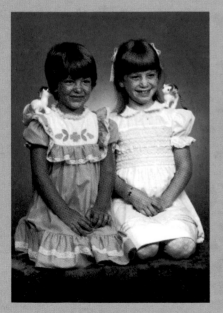

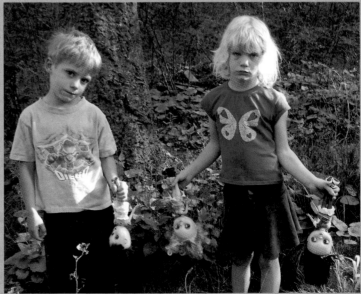

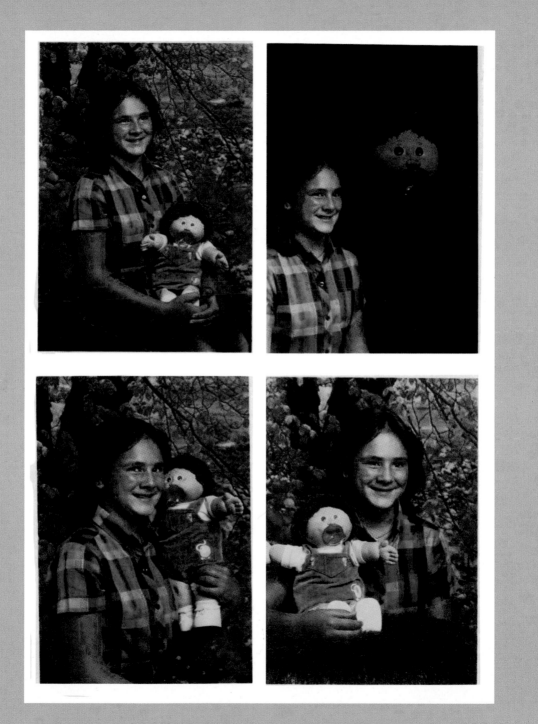

SCHOOL DAZE

While we all downplayed it, Picture Day was one of
the most stressful dates on the school calendar. The
resulting photo would, after all, be documented in
the yearbook and carried around in Mom's wallet,
ready to be whipped out whenever anyone asked
about the family. We dressed in what we (or our
parents) considered our best outfits and waited in a
painfully long line with our classmates. As we arrived
at the front the photographer offered us a flimsy
comb with which to fix our hair. We took our seat in
front of the camera and chose a backdrop—distant
planets, clusters of stars, multicolored lasers—
making it unclear whether we were posing for a
school photo or auditioning for a strange, low-budget
science fiction movie. When the photographer told
us to smile, we gave it our best shot and convinced
ourselves that maybe this year we could pull it off.

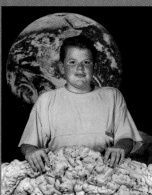
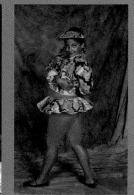

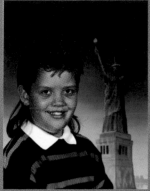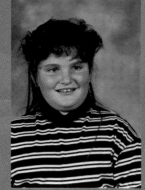

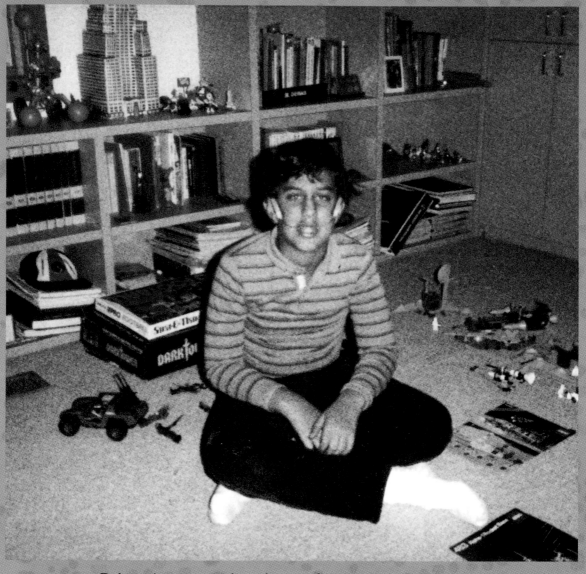

Puberty's going to be a breeze for this awkward tween.

CURLY MAN

This young man is already bulking up for next year's colored
pencil portrait.

BEHIND THE AWKWARDNESS

This is me. All dressed up at my mother's fortieth birthday—wrapped in balloons and looking like a child prostitute.

Paula
Galesburg, Illinois

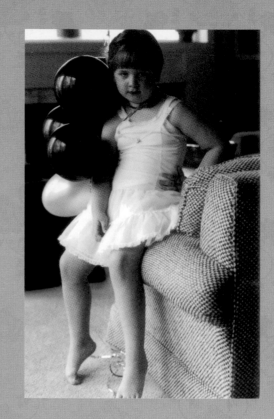

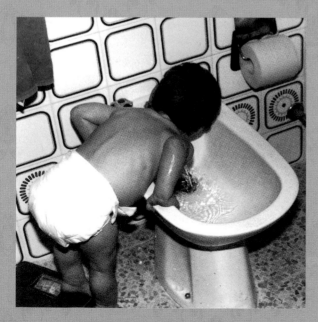

I was born in Spain and we had a bidet in the bathroom. My mom caught me using it as a water fountain and allowed me to continue (don't worry, they never used it).

Steven
Brevard County, Florida

This is me in my eighth-grade band picture. Note the American Thunder T-shirt, tight white Levi's, and the goggles . . . I mean, glasses. Not to mention the trombone. Standing at half-court.

Mary
Dora, Alabama

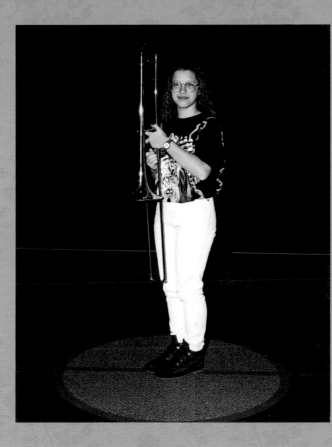

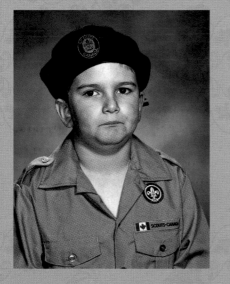

This is me in grade three. When I was fat. My mom decided it would be a good idea for me to wear my Cub Scout uniform for my school photo. I tried to make a huge smile for the camera, but I clenched my mouth so tight that it turned into a creepy frown. Yes, my parents made me go back for retakes.

Collin
Edmonton, Alberta

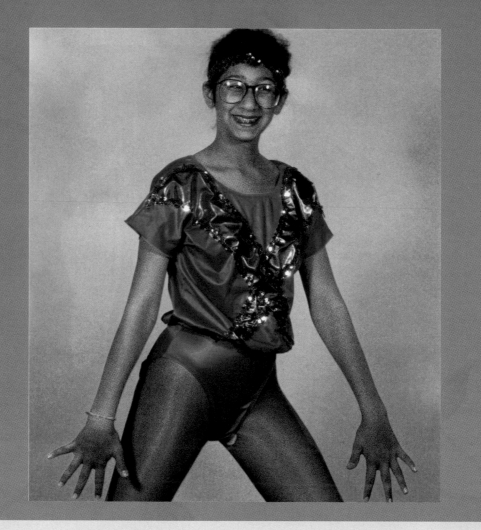

This is one of my 1988 dance recital portraits from the Dancer's Studio in Dearborn, Michigan. I was twelve years old and obviously at that stage where I had no idea what to do with my body. Everything was out of proportion; my glasses were too big, my tights were too big, and I could never get my bangs right. The photographer posed us, and for me, there was really no other option than the jazz hands.

Adriana
Dearborn Heights, Michigan

A BEAUTIFUL MIND

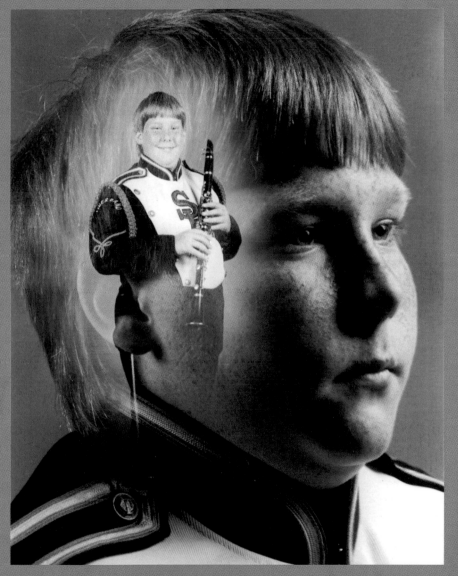

Ever wonder what the kid with the clarinet is really thinking?

4

Siblings

Childhood is a confusing journey. We all need a teammate, someone who's got our back. Someone who understands our frustrations because they live under the same roof, who has to deal with the same house rules, and the same cringe-inducing parents. This kind of support would be wonderful . . . but instead we have siblings.

They know us better than anyone, which really means they know how to press our buttons better than anyone. They steal our toys, pull our hair, punch us, and then tell Mom and Dad that we started it. We tell them to go away, but they're everywhere—torturing us in the bathroom, at the dinner table, from the bunk above. And just when we've written them off completely, something strange happens . . . they do something nice. Maybe it's confronting the school bully, giving us some good advice, or covering for us when Mom and Dad get upset. In that moment, we truly feel connected with our brother or sister; they become the partner in crime we always hoped they would be. And even though they've got us in a sleeper hold five minutes later, we're suddenly okay with it, because we now know it's just their unique way of showing that they love us.

PICKPOCKETS

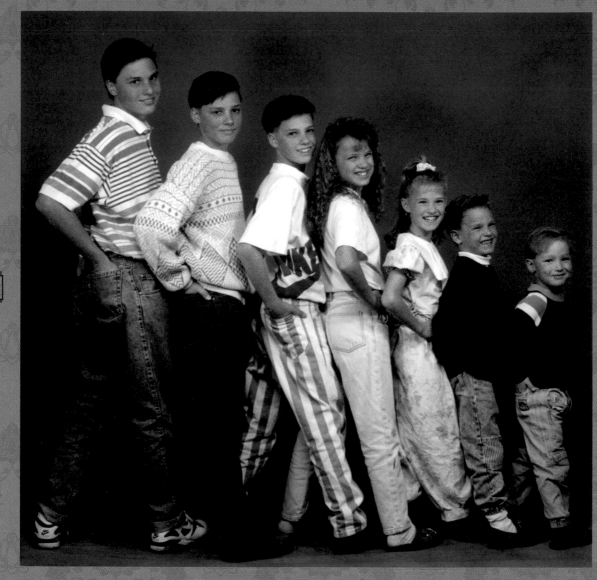

These siblings demonstrate an impressive ability to keep their hands to themselves.

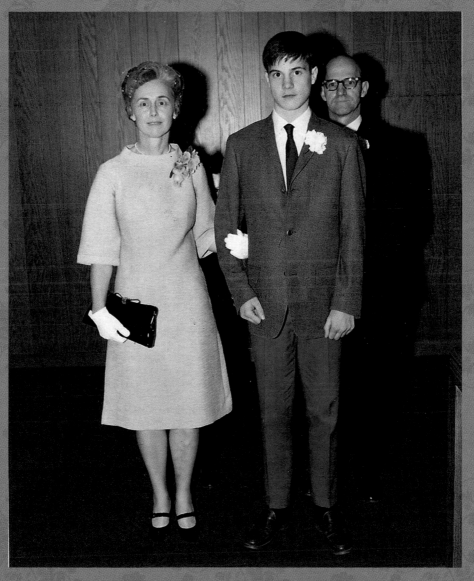

Sometimes the youngest can feel a bit overshadowed.

RENEGADES

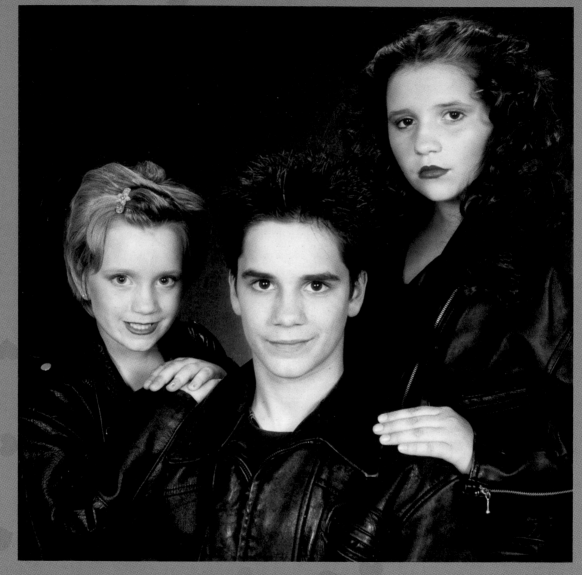

These three decided to hitchhike to the portrait studio just because they could.

IGNORE ME DOING THIS

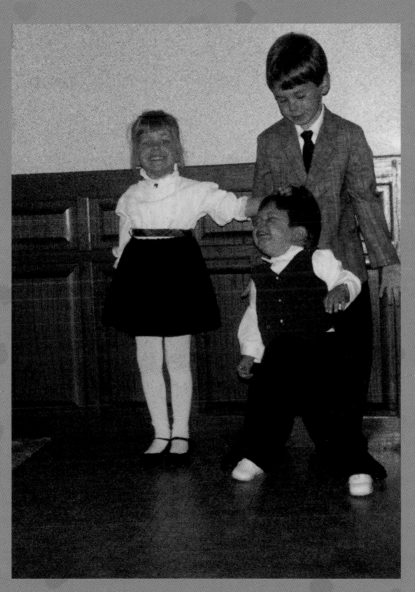

This little girl finally found something to smile about.

FEEL THE LOVE

We spend most of our childhood telling them to leave us alone. Then some photographer gives them permission to put their hands on us and we're supposed to smile about this? Not a chance.

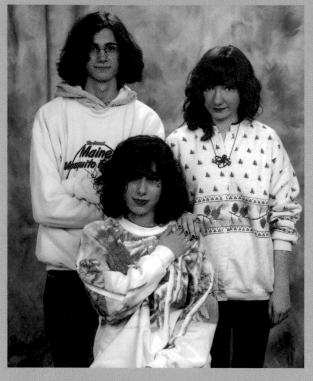

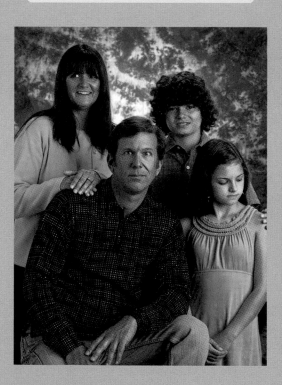

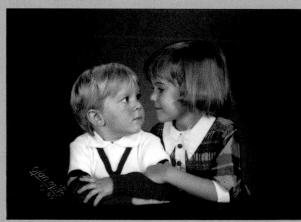

HEAD IN AN AIRPLANE

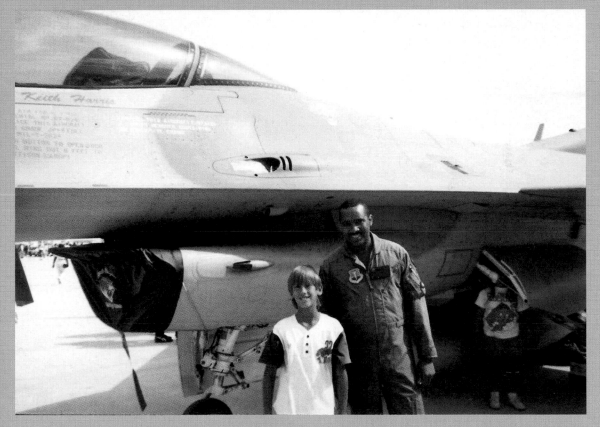

Nick's sister felt the need to prove that she was also into fighter jets.

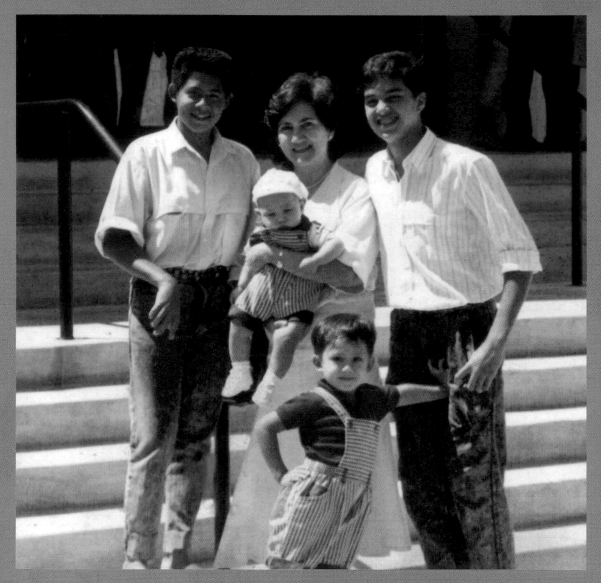

A very supportive older brother.

AGREE TO DISAGREE

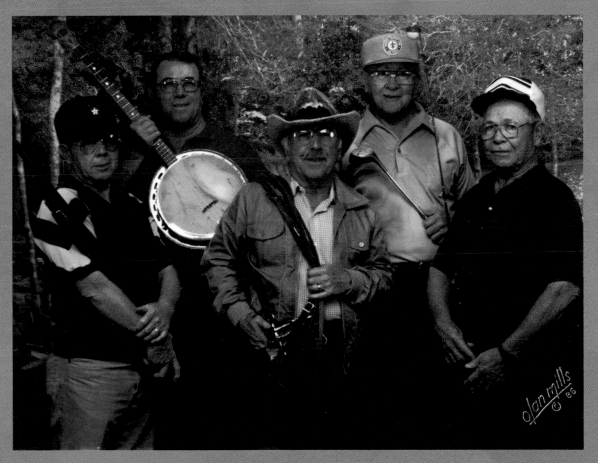

They have finally accepted their recreational differences.

BEHIND THE AWKWARDNESS

This is a picture of my brother and me taken in the mid to late eighties. At the time, we must have been somewhere between fifteen and seventeen years old and we pretty much spent all of our time in all-out teen sibling war (screaming, door slamming, insults). Why the photographer chose to make it look like he was a figment of my imagination I'll never know, but it sure would have been nice if he was.

Anna and Dane
Vancouver, British Columbia

We were always at the height of Iowa style (hence my bowl haircut and my sister's permullet). Lucky for us, my dad had connections in the optometry industry, giving us the unique privilege of wearing the latest, huge, PhotoGray lenses.

Michael and Susan
Norwalk, Iowa

I'm the one on the far right, with a black eye my sister gave me. She wanted to braid my hair; I refused and pushed her arms away. Naturally, she belted me in the face.

Tracy
Port Alberni, British Columbia

It was just after my fourth birthday when my mom and dad decided it would be fun to take my older sister, Lauren, and me on a vacation to a ski resort in Michigan. The trip would have been a good chance for some family bonding, but since I was too young to be in their ski group, I got sent to the "ski babies" club.

When my mom came to pick me up at the end of the day, she saw that I had been put underneath a table with a homemade sign that read "timeout." She was then informed that I wasn't welcome to come back the next day because I had used "extremely inappropriate language."

Frustrated, she took me back to the cabin where we were staying and left me to play a board game with my sister, while she tried to figure out what on earth she was going to do with me for the duration of our stay. We had been playing Hi Ho! Cherry-O for a while, and I really had to pee. Really, *really* had to pee. Lauren kept daring me to leave, but I knew her ways. She was a sneaky cheater when it came to these games. Given my competitive nature, there was no way I was going to let that happen. I figured I would just wait it out, but it was getting pretty difficult. I had a feeling that if I went pee right there, there was a chance nobody would even notice. So I took my chances and peed in my pants. As I finished going, my mom called my sister and me into the other room so that we could take a photo. When she saw what had happened, she was so fed up with me that she made the decision to take the photo anyway. When we returned from our vacation she sent out the picture for a Happy New Year's card to family and friends. To this day when I am reintroduced to old family friends, they say, "You don't remember me, but I'll never forget that picture of you peeing your pants!"

Alex
Chicago, Illinois

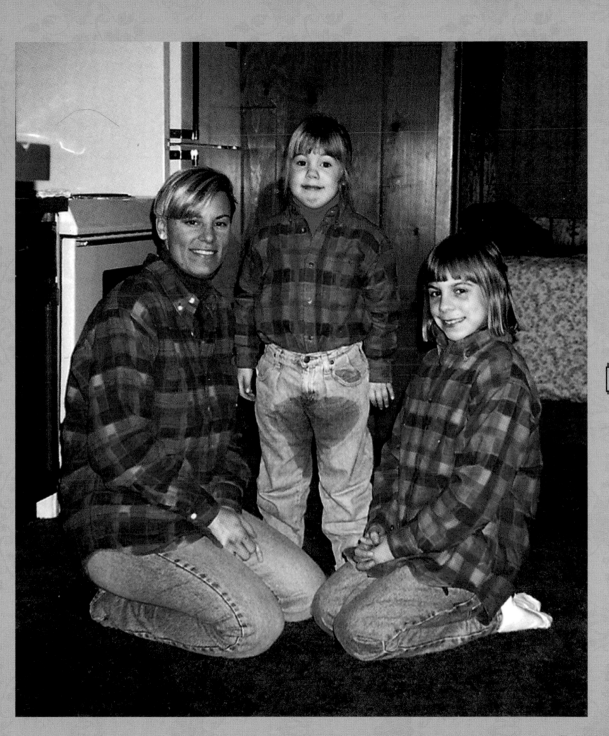

5

Grandma and Grandpa

There isn't anything a grandparent wouldn't do for their grandchild. We're their pride and joy; our every visit is treated as a holiday where they let us watch TV as long as we want and buy us the fudge pops Mom and Dad won't let us eat. They take pride in our every accomplishment (real or, more often, embellished) and brag about it to all of their friends. And to show their affection, they give us two-dollar bills, pinch us on the cheek, and tag-team call us. They tell us the same old story about the time we threw up in the middle of a restaurant and then retell it five minutes later. They wouldn't dream of missing a birth, a graduation, or a wedding, and who else can we count on to take out-of-focus photos of our every move with the camera that's constantly tethered to their wrist? And they do all this out of love, of course—unconditional love, which is the most wonderful kind. And so although these two early bird specials possess the greatest potential for awkwardness, they are the only people in the family who get a pass. Even in BluBlockers and black socks.

THE BABYSITTERS

Unconditional love just got conditional.

SPACE INVADERS

Just wait till Grandpa hears about video games.

COME TO GRANDPA

A tribute to the man who's never afraid to show his affection (even when we are).

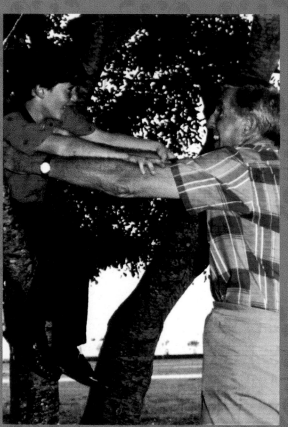

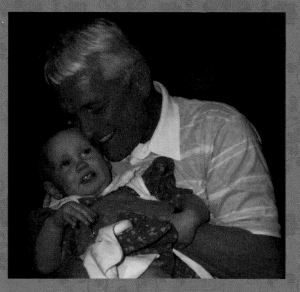

NANA COUTURE

You've heard of "Mom Jeans"? Introducing "Grandma Pants."

WILD THING

One moment she's giving us a hard candy, the next she's wielding a double-barrel shotgun and loving it. We wonder whether she has a screw loose, but something tells us she knows exactly what she's doing. You go, Grandma.

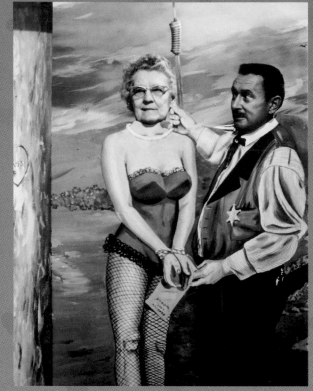

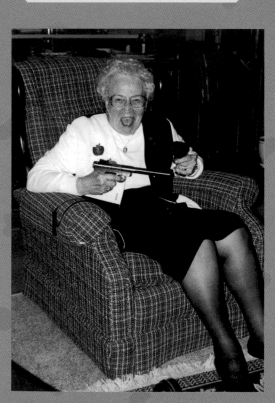

THE COLONEL AND I

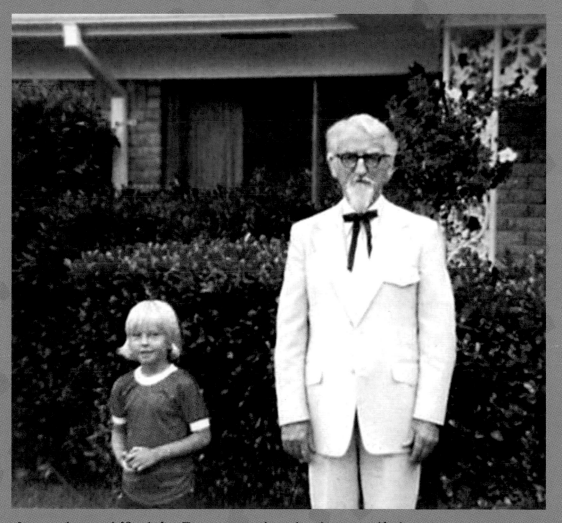

It was always difficult for Brian to explain that his grandfather was a vegetarian.

AWKWARD GRANDMA AND GRANDPA STORIES

A few years after my grandmother passed away, my grandpa started dating again. He didn't want to tell anyone because he thought that we would be upset (which we were not), but we all knew that he had been dating his old high school sweetheart, Sue. One day my cousin went to visit him and through the front window saw him sitting on the couch with Sue on his lap. My cousin knocked on the window and waved but instead of coming to the door, he threw Sue off his lap and started yelling. Sue ran off and hid under a table. Then my grandpa came to the door and let my cousin in. "What are you doing?" she asked. "Nothing," he said. "Are you just here by yourself?" she asked. "Yep, nobody's here," he said. She came in and stayed for about twenty minutes, during which time she could see Sue's feet sticking out from under the table.

Tricia
Nyack, New York

86

My mother and I went to visit my grandmother at her assisted living facility. I told my grandma about how I had recently quit my job. Her response was, "Don't worry, I know you'll find something. In fact, you're so pretty, I think you could make some money posing for photos . . . you know . . . with your clothes off."

Cecilia
Chicago, Illinois

When I was younger I took a lot of road trips with my grandparents, always sitting on the armrest between the two of them in the front seat. They *always* listened to KMA, the local farm news station. One day, when I was about eight or nine years old, they must have felt generous and let me listen to "my station." After a few seconds of commercials, the first song came on. It was "I Want Your Sex" by George Michael. Even worse was the fact that they didn't turn the station, so I had approximately four full minutes of complete torture.

Sara
Glenwood, Iowa

Here is one of my grandmother's midnight e-mails:

The twins started their state playoffs on Monday at 6:00 P.M. They won. Played again on Tuesday at 6:00 P.M. They won. Played again on Wednesday at 6:00 P.M. They won. Played again on Thursday at 6:00 P.M. They lost. Played again on Thursday at 8:00 P.M. They won by one run. They will play again on Friday at 6:00 P.M. They will play Richards, which is the team that beat them 25–3. The team that beats will win first place and the other team will win second. Never dreamed they would do so well. I have not gone to the games because of the heat and I get too nervous. Tomorrow night, Brad is going and I am also going. I will take along three nerve pills. Hope I make it. The only casualty has been Alice, who plays first base, and was hit in the mouth trying to make a catch. Just a little blood and swelling. She was worried about her permanent teeth getting knocked loose. She is fine.

Anonymous

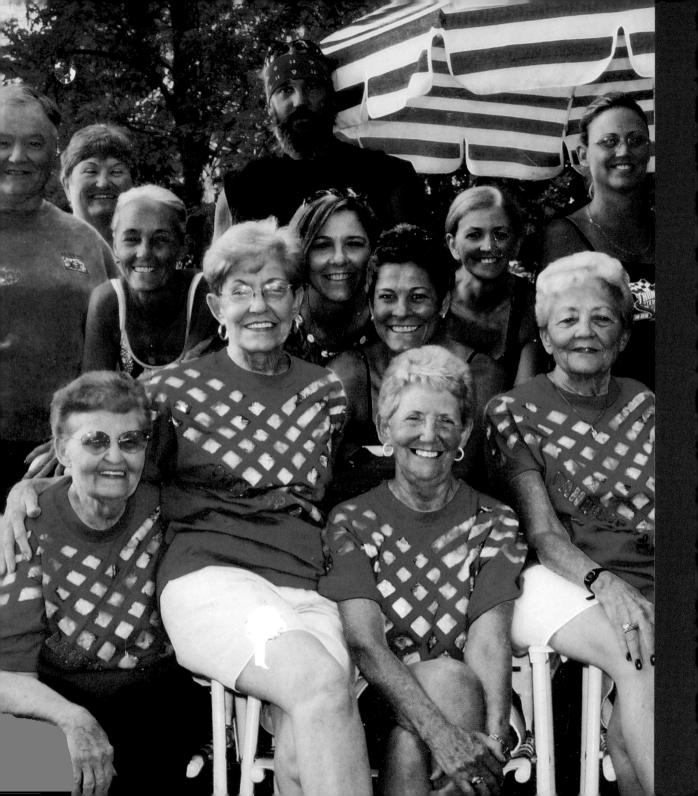

6

The Relatives

Technically, they're blood. They go by the friendly names of Uncle Jack, Aunt Rita, and Cousin Mark. We're told we're related to them and we accept it as fact because, after all, if they're showing up at the same family gatherings as we are, then they must be family. But when it comes right down to it, we must ask ourselves . . . who the hell are these people?

We see them only a few times a year. We're not really sure what they do, where they live, or how old they are. We try to make the best of it at family get-togethers and humor our uncle by watching his half-decent coin trick and listen to our aunt recount every detail of her fascinating trip to Colonial Williamsburg. As for the cousins, we're inevitably thrust into forced playtime, stiff photo sessions, and awkward silences at the kids' table.

And when it's all over and we return home with the family we can keep track of, we're not sure we know these other folks any better than we did before, but we're sure glad they're around to keep things interesting.

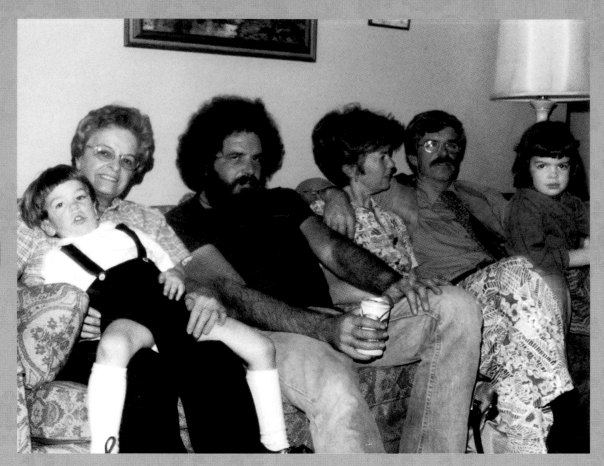

Uncle Bill is going through a rough breakup right now.

CSI

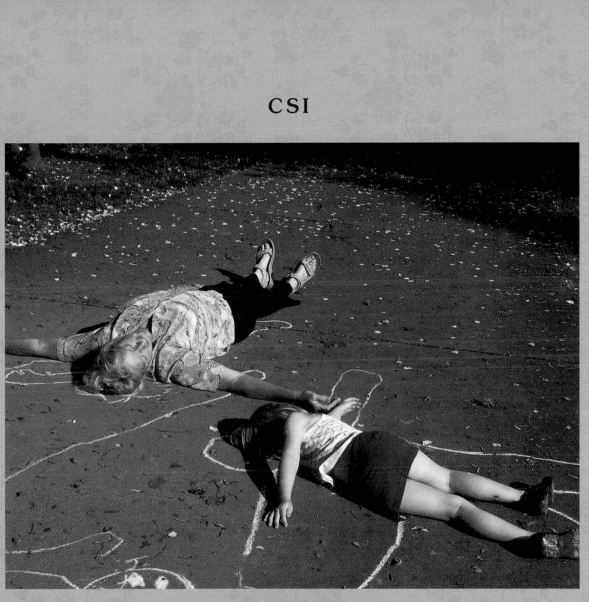

Aunt Mary passes along her extensive knowledge of crime scenes.

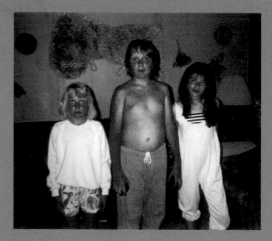

GREAT MOMENTS IN COUSIN BONDING

They're related to us and around the same age, so it's no wonder why we become instant BFF's.

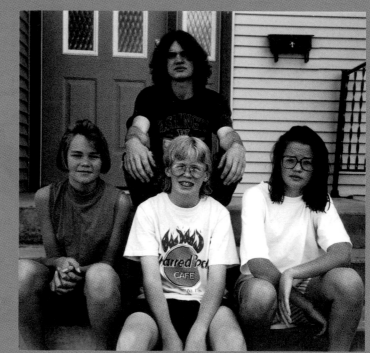

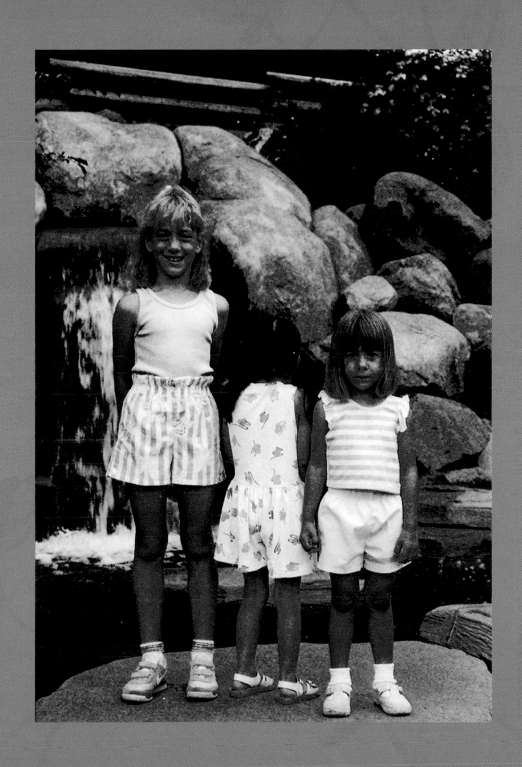

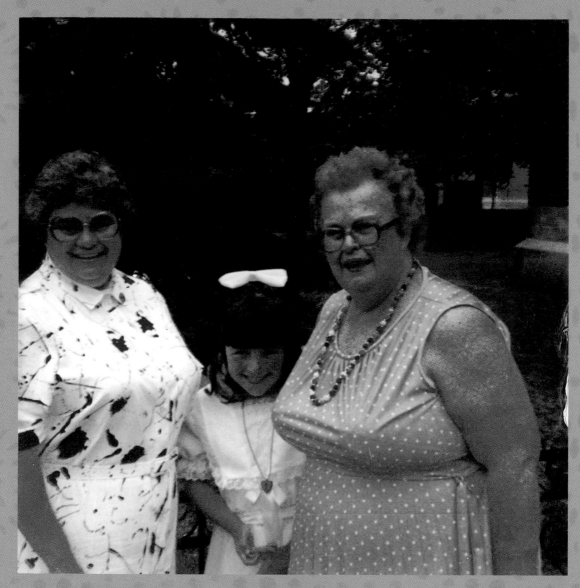

Memories of hanging with Aunt Tessa.

PANIC AT THE DISCO

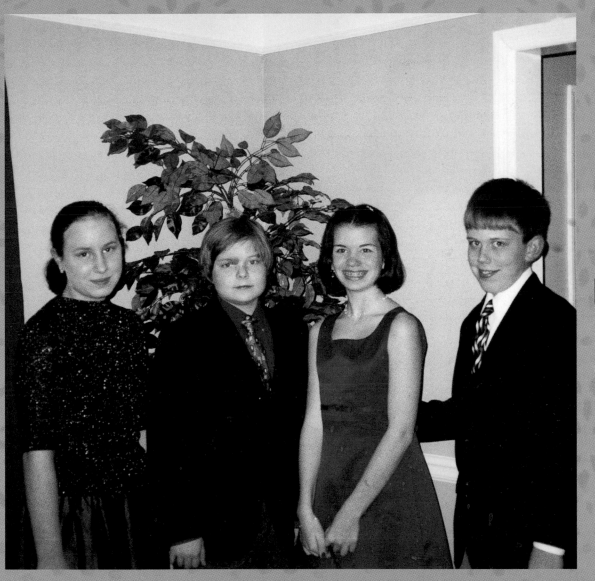

These cousins decided to opt out of the slow dances.

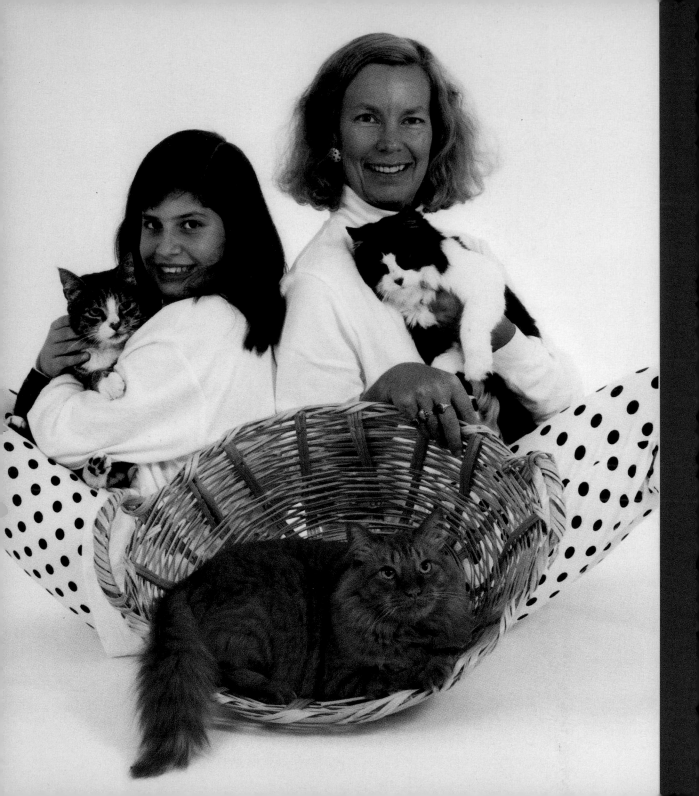

7

Pets

Pets are often considered to be the favorite member of the family. They are there for all of our highs and lows, witness all of our strange habits, and never once judge us for them. They don't talk back, don't lie to us, and consistently make us feel like we're the most important person in the world. So, why, you may ask, is there an awkward chapter about them?

Well, because it isn't the pets who are awkward. It's us! That's right. We're the ones who are guilty of dressing them in booties, bow ties, and sweaters, talking to them in a baby voice, and proudly giving them names that begin with Miss, Mister, and Li'l. We put them on gluten-free diets, hang a stocking for them at Christmas, and enter them into beauty competitions. Yes, we'll pretty much do anything for our pets because we love them so much, even though all they're really looking for is a little attention, a walk, a cuddle here and there, and a chance to chase a squirrel. So, the next time we find ourselves taking a pet into therapy because we are convinced they've got an emotional issue to resolve, we should remember that we're the crazy ones.

DOGGIE STYLE

Not everybody was thrilled with their position in the family.

Aspiring "crazy cat ladies."

PET-A-LIKES

We may be a lot closer than we think . . .

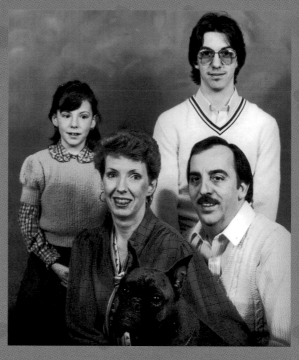

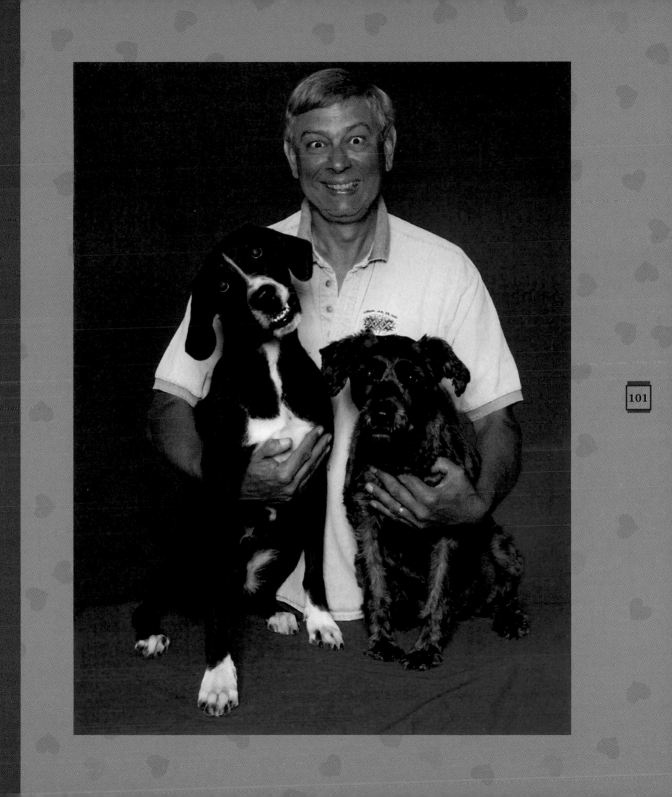

WHAT ABOUT ME?

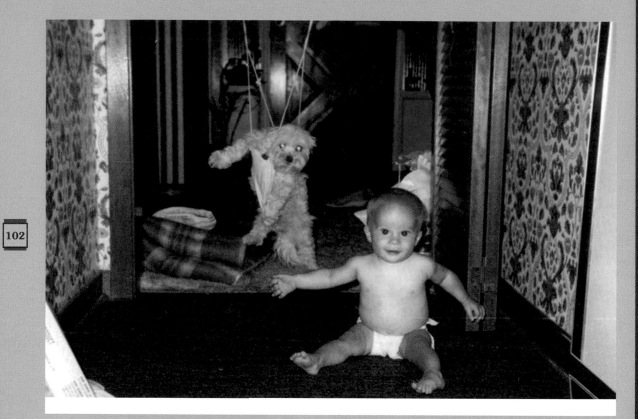

Looks like Miss Muffet has been feeling a little left out lately.

WHERE THE WILD THINGS ARE

Some families decide to forgo the traditional dog or cat and adopt a more unconventional animal companion. That doesn't mean they love their not-so-cuddly creatures any less.

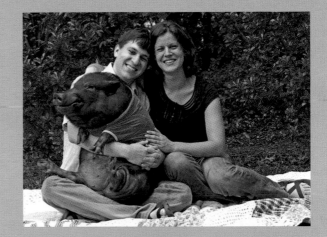

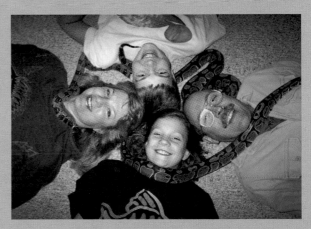

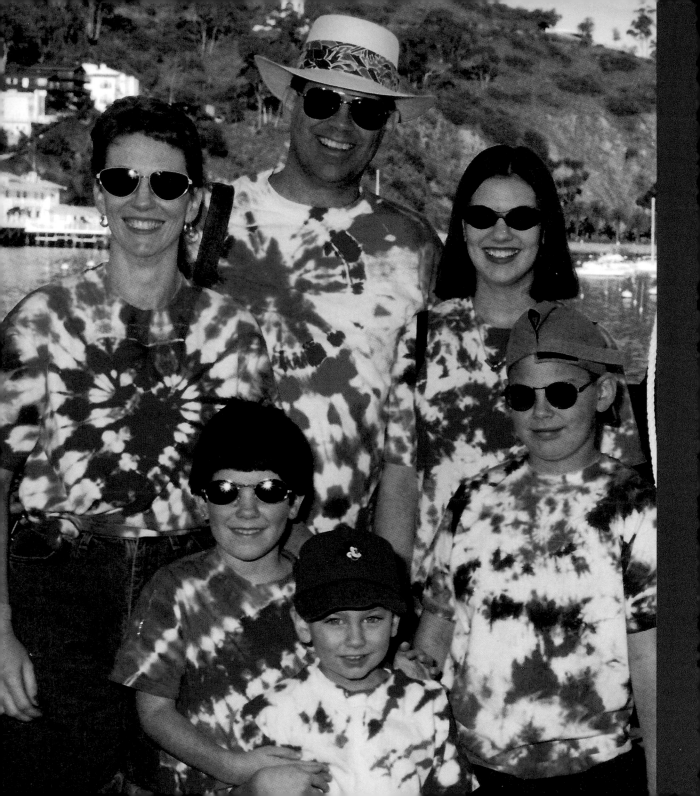

8

Vacation

It starts with the best of intentions. Mom and Dad, feeling that the family needs to spend more time together, decide that we should take a vacation.

Reluctantly, we load up the family wagon and depart for our destination. As our parents break into song, asking us to join in for a group sing-along, we are faced with the harsh realization that this vacation is going to be far, far worse than we feared. When we arrive at the hotel, all we want to do is hang out by the pool, but instead we have to follow Dad, who is covered in too much suntan lotion (even though it's cloudy) and repeatedly gets lost as he tries to keep up with his strict itinerary of landmarks we couldn't care less about. All of which is documented in staged photo ops, where we're told to look like we're having the time of our lives—not an easy task when you're standing in front of the National Archives. And as the vacation continues and we fight with our siblings for the bed near the window, eat at restaurants where the waiters are dressed like pirates, and witness Mom and Dad getting a little too tipsy, the only thing that gets us through the experience is knowing that if we can survive the next few days, we'll be back in the sanctuary of our own home, where we can get some much-needed rest and relaxation from our vacation.

It's the quality family time they've waited for all year.

BLOWN AWAY

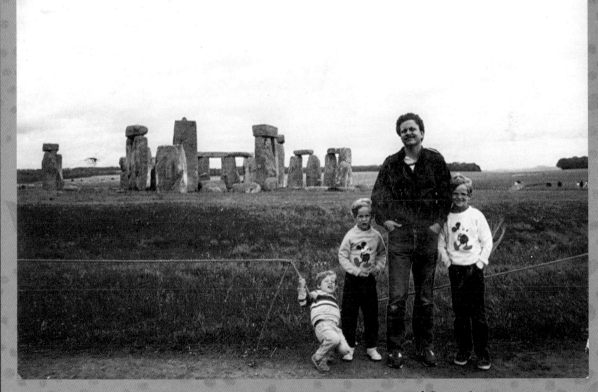

Not everyone can handle the awesome power of Stonehenge.

THE LIFE AQUATIC

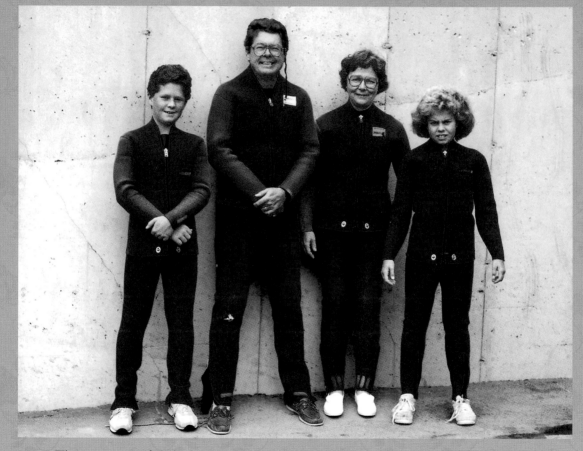

This resourceful dad wasn't going to let a little rain spoil the vacation.

THE HAPPIEST PLACES ON EARTH

Theme parks look like they are the ultimate vacation destinations. With rides for all ages, mountains of sugary sweets, and spectacular shows, these magical kingdoms are so magical, they will take a happy family and have them cursing each other in less than an hour. Guaranteed.

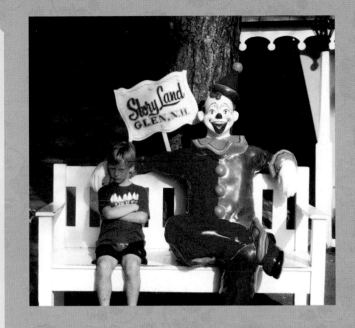

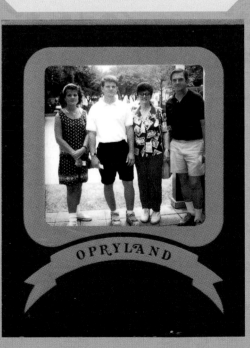

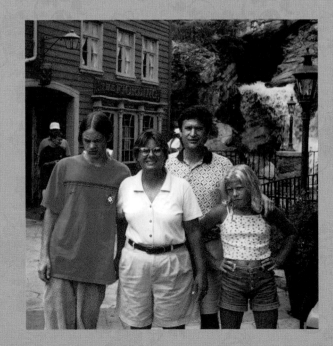

THE GREAT WHITE HOPE

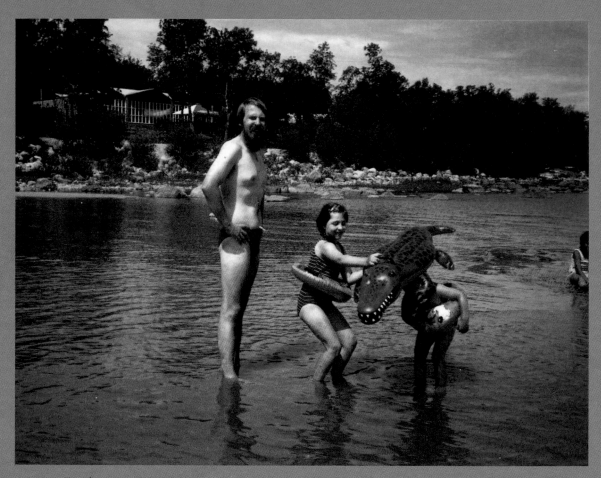

Dad wore a bathing suit that would complement the color of his tan.

JOYRIDE

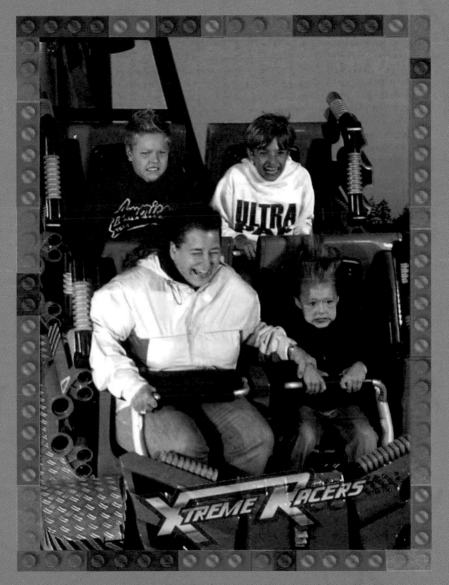

This young man decided the teacup ride was more his speed.

THE WALLFLOWER

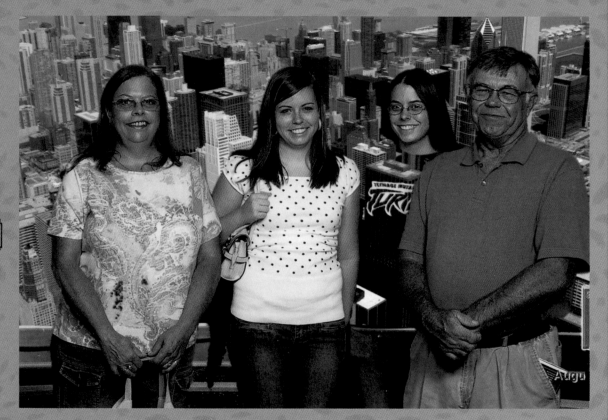

Tessa picked the wrong day to wear green.

THE ROCKETTES

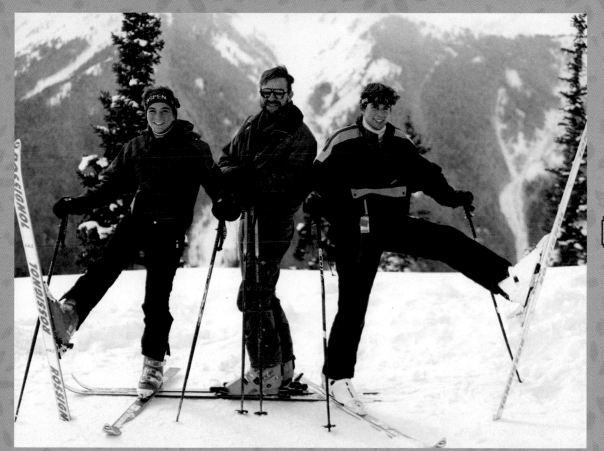

Sometimes the background is enough.

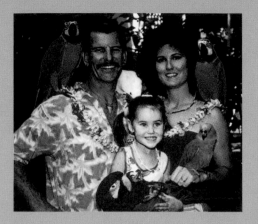

THE BIRDS

Nothing says "tropical paradise" like returning home with a souvenir photo of you and your family being swarmed by wild parrots.

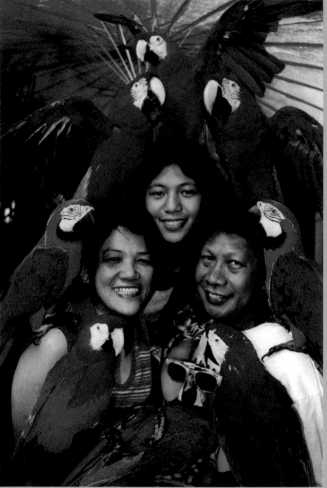

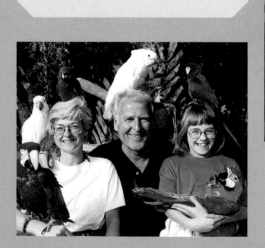

EASY RIDERS

Even the railing felt this one was uncomfortable.

BEHIND THE AWKWARDNESS

My youngest daughter doesn't fare so well with long airplane rides. One year, we traveled to Paris on Christmas Day, and visited the Eiffel Tower. Once we got down, between the cold and the fact that we'd just gotten off of the plane, my daughter had to vomit. My older daughter thought it was funny, so she decided to take the picture while her sister was getting sick. And my husband and I just decided, oh well, we might as well smile!

The Burns Family
Glen Head, New York

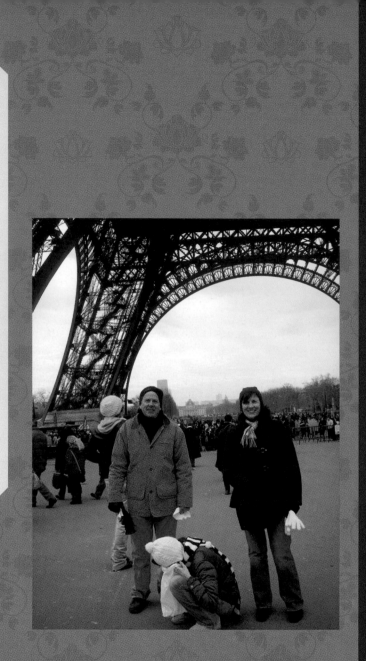

This picture is from a family trip to Disney World in 1985, right before my parents divorced. Everyone had issues at the time. I (the oldest on the left) was back for the summer after my first year at college and was resenting my temporary loss of newfound freedom (note the finger). Mom had been away "studying French" in the South of France with youngest son Ryan (far right). That left Dad alone with middle son Rob (second from left), who had the misfortune of being in high school during the peak of the New Wave fad. This trip to Disney World was an effort to have a "normal family vacation."

After we flew across the country and felt jet-lagged, Dad tried to take a family picture. After several failed attempts, he screamed, "Can't I get *one* picture, *just one,* without everyone screwing around?!"

Anonymous

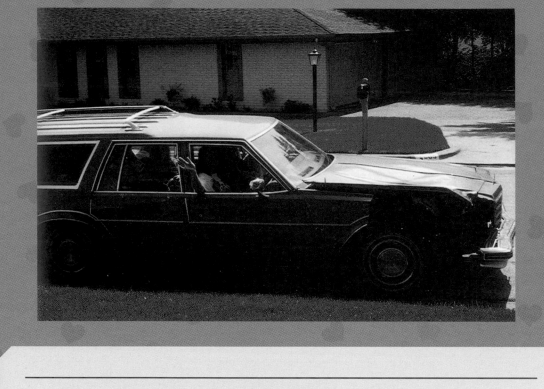

The car originally belonged to my grandmother and she passed it down to my father. Shortly after, my dad had a wreck, but being the frugal man he is, he decided that the car drove just fine and didn't look bad on the driver's side. When this picture was taken my mom, dad, grandmother, aunt, cousins, myself, and several dogs were on our way to Galveston, Texas. To make the summer road trip more comfortable for everyone, my parents never used the air conditioner.

The Carpenter and Horton Family
Arlington, Texas

Most of these are of my mom, brother, and me because my dad is taking the photo. He usually takes several billion per trip. Our family vacations are very rigorous; everything is planned to the last detail and it's all sightseeing, which makes it very tiring for the rest of us. Not him. Even when we are about to collapse on a national monument or castle from the Middle Ages, he marches on.

Lia
Palo Alto, California

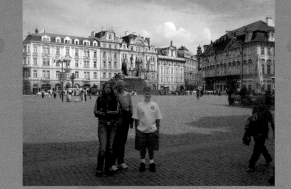

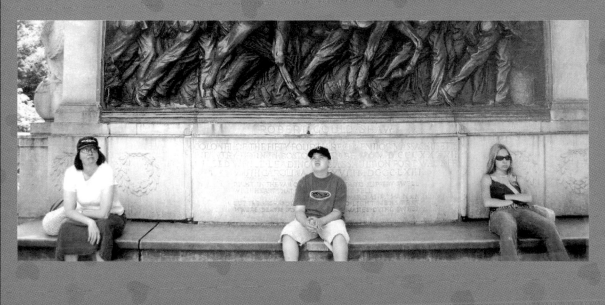

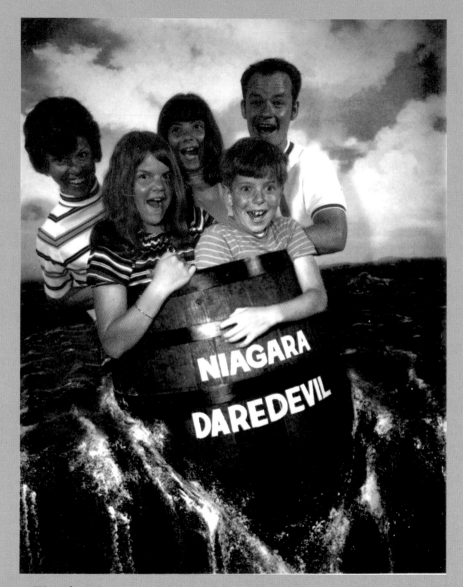

NIAGARA DAREDEVIL

This family is just plain giddy about falling to their death.

THE SAVE

Whatever you do, do not drop the dog. We repeat. Do not drop the dog.

AWKWARD VACATION STORIES

When I was ten years old, my parents took us on vacation to a water park. I told my dad I had to go to the bathroom; he pointed to a building and let me go in by myself. When I got in, I noticed there were no urinals, and none of the stalls had toilets in them. Confused, I went into a stall anyway, pulled the curtain closed behind me, and did my business all over the floor. When I got out, we started walking away when another man with his son asked my dad if we knew of any bathrooms nearby. My dad pointed to the building that I had just exited. The man said, "No, that's just a dressing room to change in and out of bathing suits." My dad said that was not true, as I had just used the bathroom in there. The other man insisted and my father started to get angry: "Are you calling my son a liar?" My dad told the man we would all go in together to prove my innocence. Despite my objections, the four of us went in, and when my dad whipped open the curtain to the first stall . . .

Kevin
North Smithfield, Rhode Island

When I was a teenager, my family went to Philadelphia to tour the sights. My dad decided to wear bright yellow pants with a red and yellow Hawaiian shirt that day, so he looked like a total tourist. I was already embarrassed by what he was wearing, but then he ramped it up a notch. After listening to a tour guide explain the history of the Liberty Bell, my father raised his hand and said, "Excuse me, miss, your bell has a crack in it."

Crickets.

Suzy
Lexington, Kentucky

My family took a two-week camping trip to the Grand Canyon when I was ten. After packing up the wood-grain station wagon, my parents, older sister, the family dog, and myself climbed into the car. As my dad was backing out of the camping site, he backed into a ditch where big clumps of grass became stuck in the bumper. When we hit the border of Arizona, the toll guy asked us if we were transporting any fruit over the border, and my dad replied, "No, but we have a little grass in the back."

Teri
Westbrook, Maine

On a trip to the Baseball Hall of Fame in Cooperstown, New York, my two brothers and I slept on three small fold-out cots wedged side by side in the middle of our hotel room. I was nine, my brother David was seven, and my youngest brother, Andy, was four. One morning, David awoke to find his sheets soaked in urine. Embarrassed that he'd wet his bed, he sheepishly woke our parents in the next room. Our mom proceeded to clean him up, only to discover that although his pj's were damp (and his sheets soaked), his underwear was mysteriously dry. This was impossible, of course, and so we racked our brains, trying to make sense of this anomaly . . . when we noticed Andy sitting Indian-style on his dry cot, grinning, a damp patch at the front of his pajamas. It didn't take an Encyclopedia Brown to piece it together. In the middle of the night, Andy had rolled onto David's cot, peed with abandon, then rolled back onto his own cot for a dry night's sleep.

Mark
Mount Kisco, New York

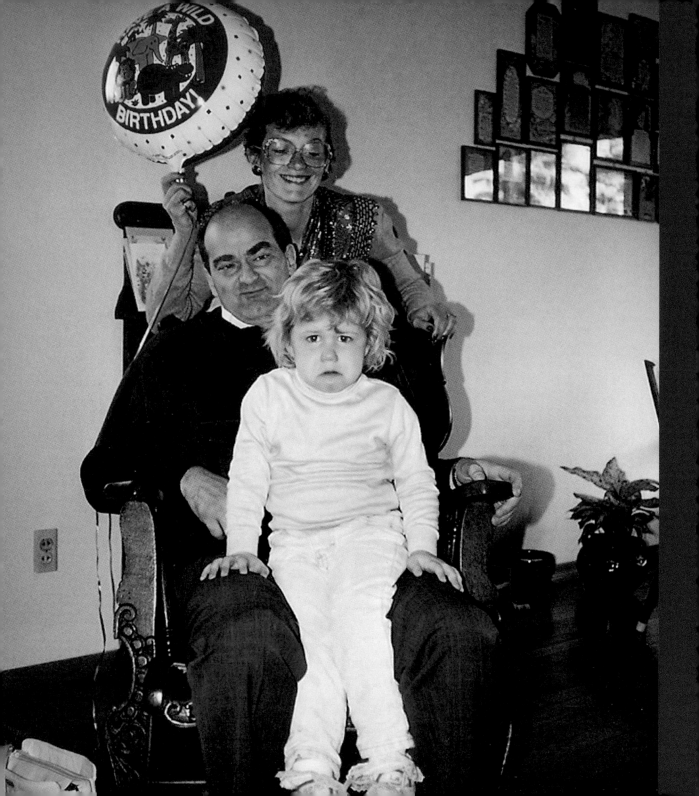

9

Birthdays

We wait an entire year for the one day that is all about us. Our parents can't get angry with us and our siblings can't put us in a headlock. Instead, they must treat us like royalty, shower us with gifts, and wait to have a piece of cake until we've been served. In theory, it's the most awesome day of the year and so we plan for it months in advance, put together our guest list, and fantasize about the closest thing we can imagine to nirvana. Then the big day arrives . . .

. . . and we quickly discover that the fantasy is just a fantasy. We wake to calls from distant relatives singing off-key renditions of "Happy Birthday to You." Our siblings, who we were sure would honor the truce, sabotage our special day by sticking their fingers in the cake before we've been served. We are forced to open a stack of corny birthday cards, and end up with boxes of clothes we'll never wear. And in the ultimate violation of birthday law, our parents find a public moment to let us know that we're being "a pain in the butt." One big letdown after another, and we vow to ourselves never to celebrate another birthday again—that is, until next year. Only 364 days to go . . .

PARTY LIKE IT'S YOUR BIRTHDAY

Another "boring" b-day moment brought to you by Chuck E. Cheese!

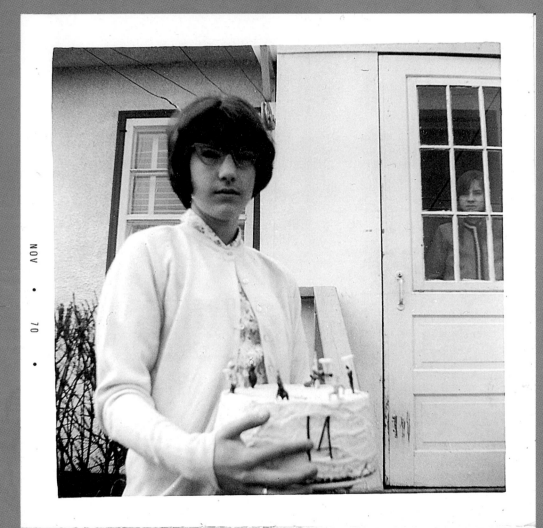

NOV • 70 •

Shauna had to make some last-minute cuts to the guest list.

BEHIND THE AWKWARDNESS

I remember that I was tired. I had been under the coffee table for a good half-hour before I decided to come out. My uncle was attempting to cheer me up with a sparkler. This only worsened my mood. Also, the cake was sub-par.

Autumn
Ottawa, Ontario

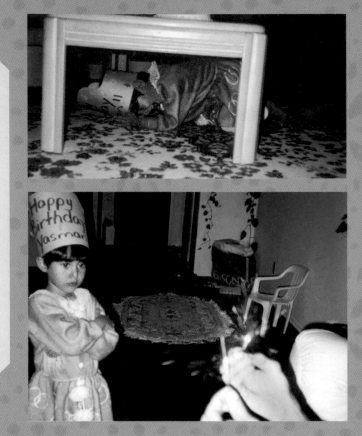

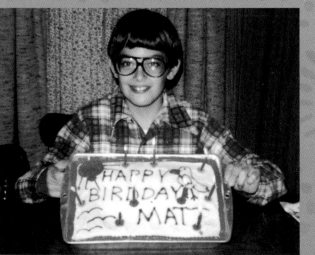

Our last name is Nightingale and my dad is a big fan of the pun. This combination led to a memorable birthday cake on my ninth birthday.

Matt
Tulsa, Oklahoma

When I show this picture to people, I describe it as the picture that defines my childhood. My brother was always goofing off and trying to be the center of attention, even on my birthday. He just *had* to upstage my pink plastic Corvette, and all I could do was glare. I spent many years doing that.

Stephanie
Wilsonville, Oregon

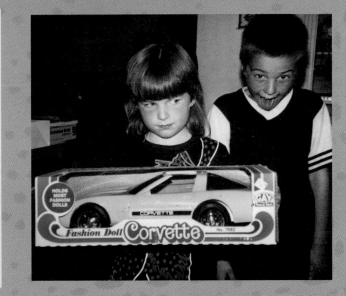

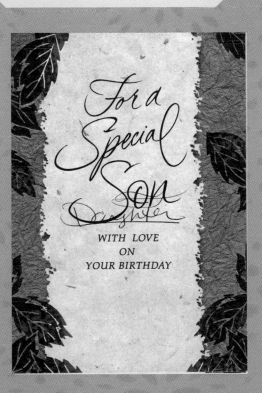

For a Special Son ~~Daughter~~

WITH LOVE
ON
YOUR BIRTHDAY

This is the card that my mom and dad gave me. They were obviously very busy with planning the party and all the "Happy Birthday Daughter" cards were sold out. I asked my mom what she was thinking when she did it . . . she has never given me a straight answer.

Jessica
San Antonio, Texas

Apparently, turning sixteen means that you can light up more than just the candles.

BETTER WITH AGE

The older we get, the more awkward our special day becomes. Our kids get into epic fights, the cakes get fruitier, and our only wish is that everyone stops blowing the damn party favors.

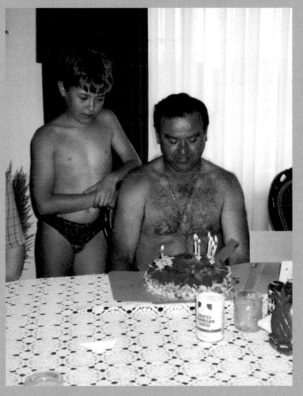

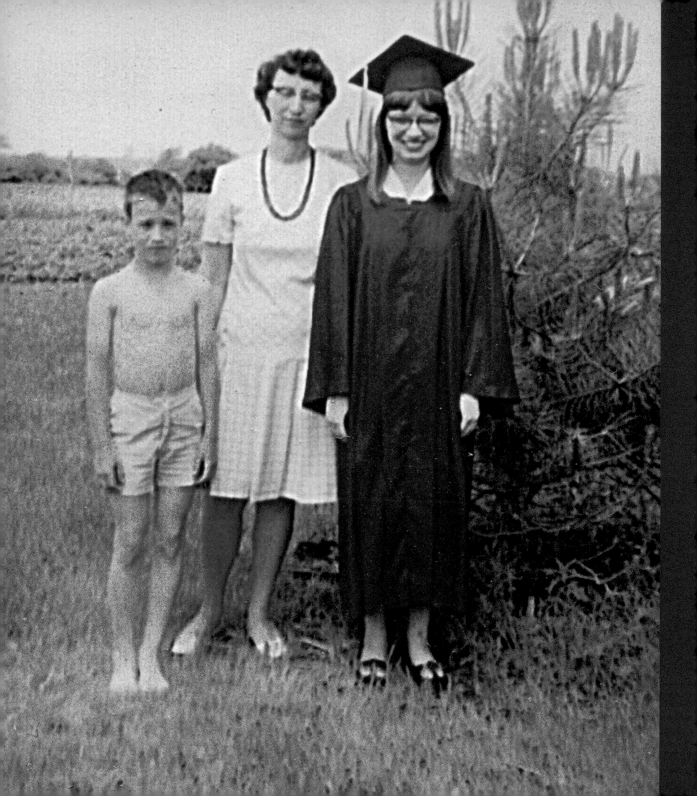

10

Graduation

Graduation is a bittersweet time in our lives. On the one hand, we're excited to have passed our final exams and achieved a major milestone. On the other, we are moving on to the next stage of life. Whether we're transitioning from high school to college or college to the real world, we're at a crossroads, we're confused, and we have a lot of new decisions to make. But even with all of that pressure as we stand in our cap and gown, there's something else that stresses us out even more.

For the first time in four years, our entire family has invaded our home away from home—our "safe zone," where we are surrounded by friends and free from the awkward bondage of family. But with a familiar honk, the car that we spent a childhood fighting in pulls into the school parking lot and we see them approaching: our parents and grandparents wearing shirts with "I Kissed the Graduate" monogrammed in huge letters across their chests, and our pissed-off siblings, who blame us for being dragged there to sit in plastic folding chairs and listen to some contrived speech about "changing the world." We realize that despite our accomplishments, our families are one institution that we will never be able to graduate from.

A WARM EMBRACE

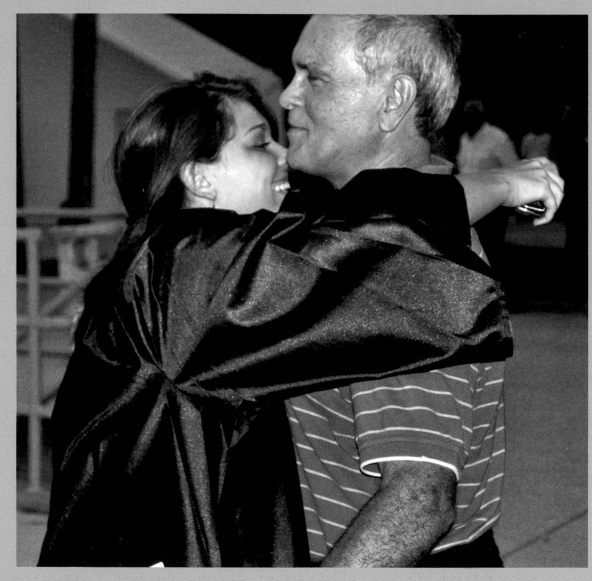

CJ was finally able to get the acceptance she was looking for from Dad.

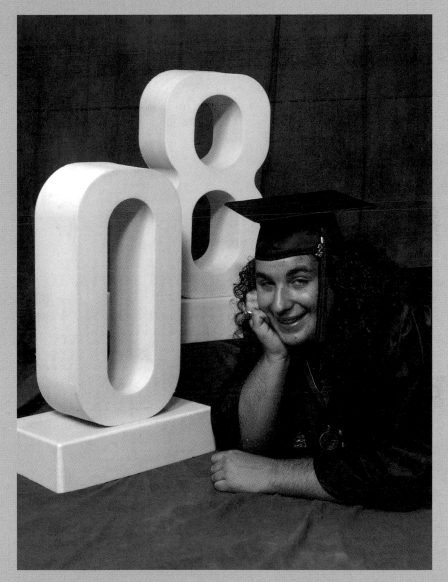

He would always look back on that special year and think, "What if?"

IS IT OVER YET?

It's our special day and our siblings are just so excited to be there to share it with us.

BLOWING IN THE WIND

This graduate is determined not to be another face in the crowd.

BEHIND THE AWKWARDNESS

This is my father and me at my eighth-grade graduation. I was attending a college-prep school and he was meandering through life as a full-time hippie.

Greg
Ann Arbor, Michigan

My mom dressed me for graduation in a powder blue suit and pointy white Capezio shoes. She thought I looked really stylish and wanted to keep taking photos. All I could think about was getting home and taking off my *Saturday Night Fever* special.

Chris
Los Angeles, California

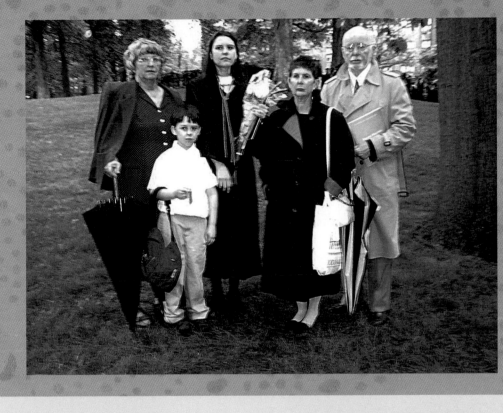

My parents had a contentious marriage and divorced when I was five. My mom always had a habit of airing dirty laundry during family get-togethers, so after the divorce, my parents rigorously avoided each other. My dad married my stepmother when I was eleven. This picture was taken when I was twenty-four, and I think my graduation dinner marked the first time my parents and stepmother ever intentionally made plans to eat a meal together. At the point the picture was taken, the college still hadn't decided if graduation was going to be held outside or in the gym (there was a light sprinkle that day). We were all running around campus trying to figure out where we were supposed to be as it intermittently rained on us. I'm not sure who decided to take the picture, but my sister made sure she was behind the camera.

Victoria
East Longmeadow, Massachusetts

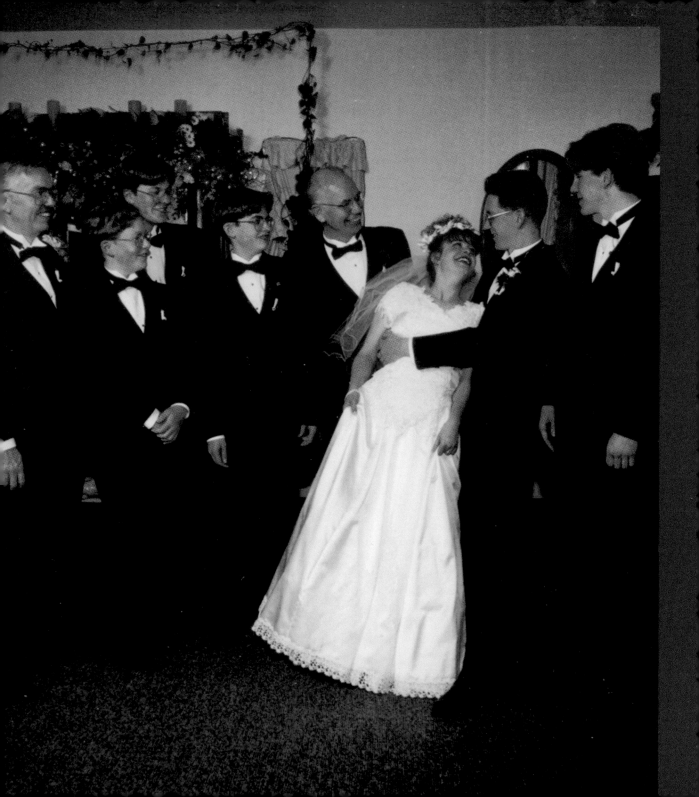

11

Weddings

It's one of the most important days of our lives, so no wonder it is filled with anticipation and excitement. We're not talking about the happy couple sharing romantic vows and declaring eternal love for each other. We're of course referring to the real drama of any marriage—the joining together of the happy couple's families. And in case we were wondering how that was going to turn out, perhaps we got a hint during the wedding planning, when the two families disagreed over who was paying for everything, how many guests each side could invite, and whether our cousin really needed to sit at the head table.

And the results rarely disappoint: parents getting a little tipsy and delivering sloppy toasts, normally restrained relatives letting loose on the dance floor, and in-laws engaging in passive-aggressive conversations, planting the seeds of conflict that will fully blossom a few years later. As for the happy couple themselves, they're too busy posing for photographs with relatives they never knew existed, nervously performing an overly choreographed first dance, and smearing cake all over each other's faces to realize that from this day forward, every family gathering just became twice as awkward as it was before.

IN HIDING

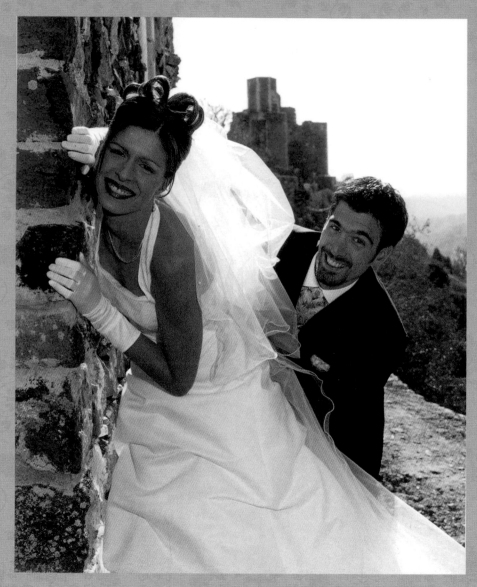

Nobody will *ever* spot these inconspicuous newlyweds.

STAR TREK: THE NUPTIALS

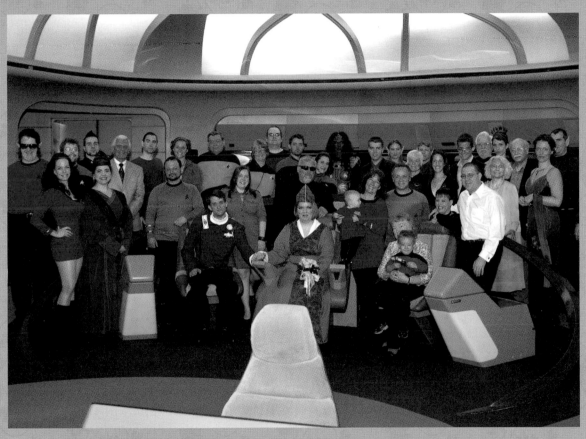

The dress at this wedding was Starfleet optional.

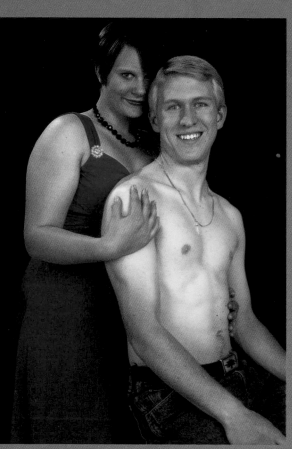

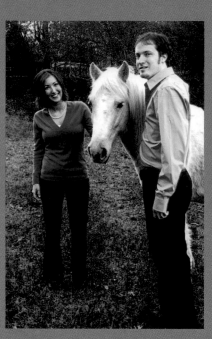

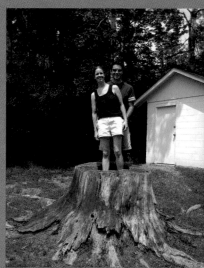

WE'RE ENGAGED!

Dropping to one knee to ask your partner to spend the rest of your lives together may feel sufficiently romantic for most of us, but apparently this display of love and commitment just isn't enough for everyone.

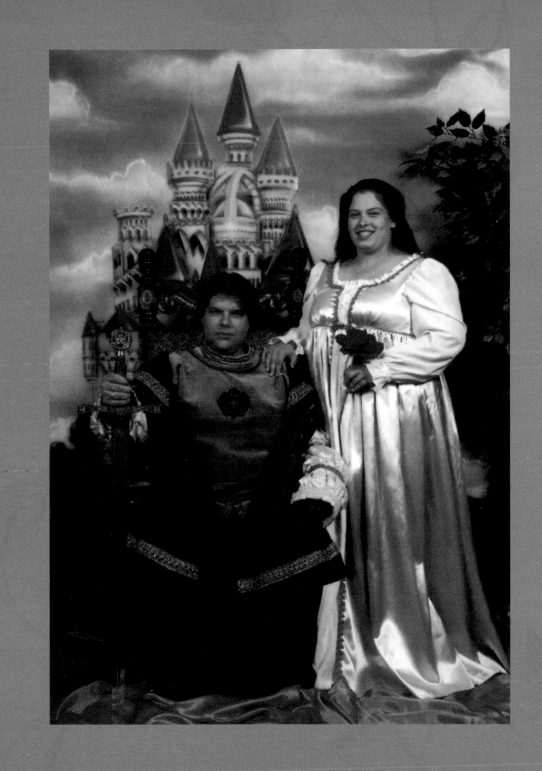

GETTING AN EARFUL

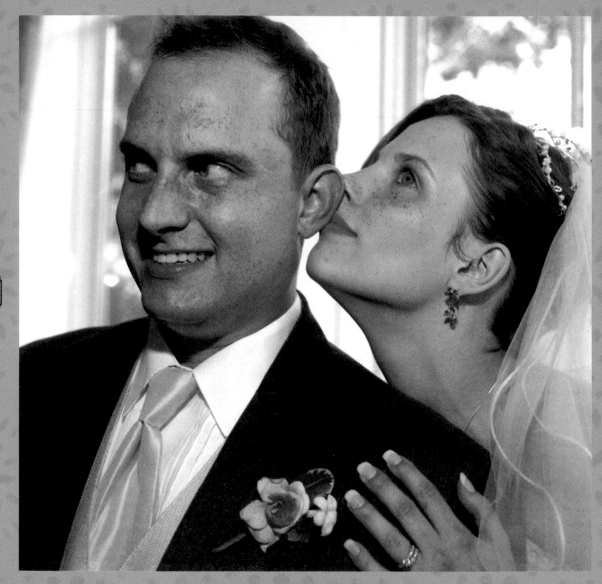

They aren't just for whispering sweet nothings.

THE THIRD WHEEL

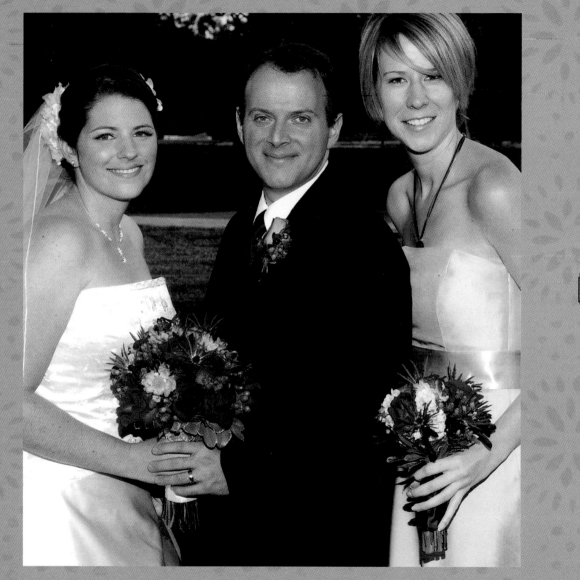

Things only got worse when Heidi showed up for the honeymoon.

AWKWARD WEDDING STORIES

When my husband and I first became engaged, we went over to his mother's house to make the announcement official. We walked into the living room; his arm was around my shoulder, and she was sitting on the sofa. He said, "Mom, we're getting married!" She lowered her reading glasses; she looked at her son; she looked at me; she looked back at her son and replied, "Oh, really? To whom?"

Lynda
Billings, Montana

It was the rehearsal dinner the night before my wedding. One of my bridesmaids, who is one of my dearest, oldest friends, had lost a considerable amount of weight before the wedding and we were all telling her how great she looked. Then my husband-to-be's aunt sidled up next to her at the bar, where she and my maid of honor were ordering beers. The aunt looked over at my bridesmaid. "So, you pregnant or just had a big dinner?"

Nicolle
Longmont, Colorado

My in-laws had been divorced for over twenty years at the time when my husband and I decided to get married, so they had limited contact while my husband was growing up. The morning of our wedding my father-in-law, his other children, and his current wife arrived at the church and began introducing themselves to other family members. He promptly went up to a woman standing near me and said, "Hi, you must be Janet's mother. So, nice to meet you," to the horror of all who were there. Once the shock wore off, she responded, "No, I'm Bonnie, your ex-wife."

Mackenzie
Provo, Utah

The most embarrassing moment of my wedding wasn't when the piano player *continued* to play the wedding march after I had stood at the end of the aisle for over five minutes. It was during the reception, when it was time to "shoot" the garter. My husband, having no idea what to do, did not wait for a group of young, single men to gather. He just took the garter off and proceeded to shoot it at a table of dining guests. The young ring bearer, seeing where it landed, picked it up and ran off with it. This didn't bode well for the rest of the single men at the wedding, and now an eight-year-old has my garter.

Megan
San Marcos, Texas

The morning after my wedding, the wedding party and family and friends were all checking out of the hotel. My father, fresh out of the shower, looked out the window and saw his friend in the parking lot below. As a joke, he knocked on the window to get his friend's attention. Unfortunately, his friend didn't hear him, but my bridesmaid, Tracy, heard it as she walked out of the hotel and looked up to see my father standing naked in the window, banging on the glass as if he was trying to get her to look.

Karen
Los Angeles, California

The parents of the bride showing their support for each other's forearms.

AIR SAX

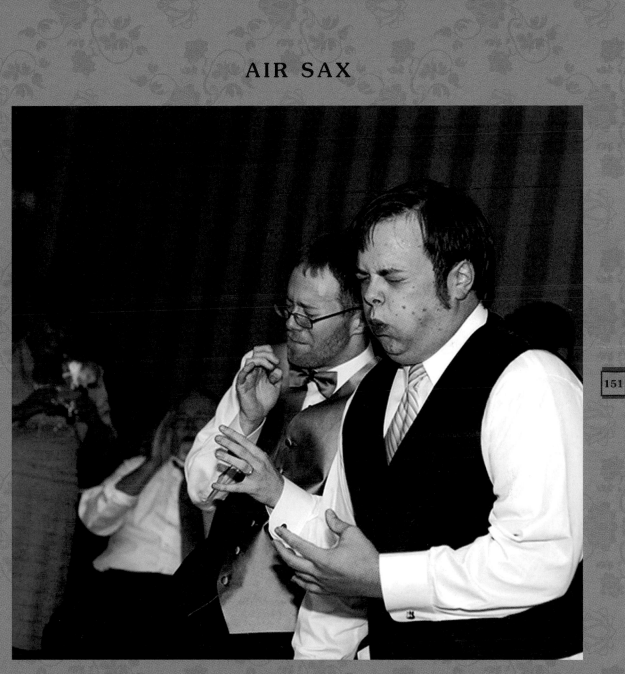

What guy doesn't dream of rocking out on a woodwind?

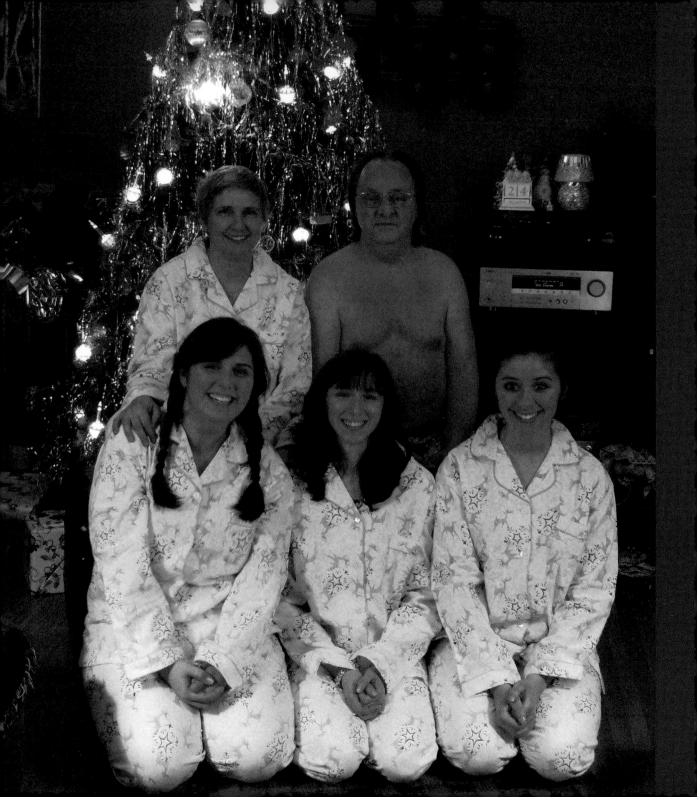

12

Holidays

Holidays make everyone in the family go a little nuts. Maybe it's the pressure of getting to the Easter egg hunt on time, the dilemma of finding the perfect Halloween costume, the stress of preparing the annual Thanksgiving feast, or the anticipation of finding out what's under the Christmas tree. In the name of holiday spirit, we spend an entire day endeavoring to turn a simple chicken egg into a masterful work of art, or wear costumes made by Mom and Dad, who swear to us that being a construction-paper tube of toothpaste will make us the envy of all the kids in the neighborhood. We dress up as Pilgrims and Indians and reenact the most unrealistic version of the first Thanksgiving ever. We find ourselves carrying candles and parading around the neighborhood singing songs about figgy pudding to strangers. But as ridiculous as holidays and their traditions may be, at least the whole family suffers together.

BASKET CASES

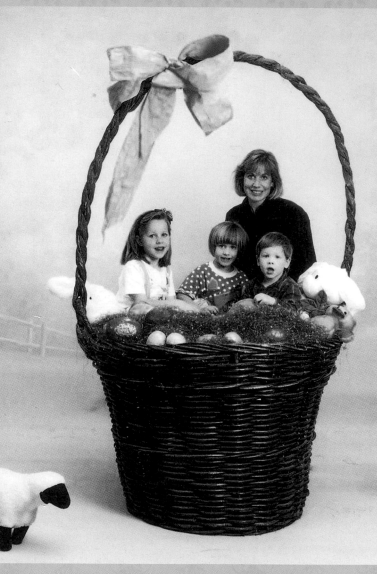

AFP Essential: Oversized props.

EASTER'S FINEST

Open to interpretation.

MOST AWKWARD HOLIDAY MASCOT

Frightening children has long been the mall Santa's domain, but AFP would like to recognize another awkwardly intimidating holiday mascot: The Easter Bunny. Take a cute, cuddly creature with buck teeth and a big smile, blow it up to giant, freakish proportions, and you've got all the ingredients you need to seriously traumatize a child.

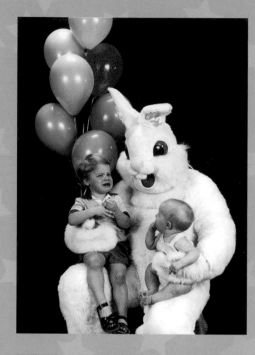

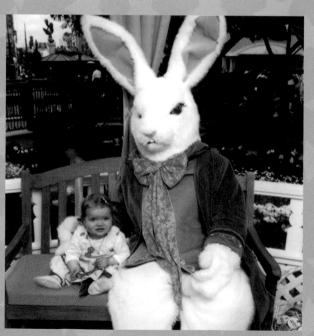

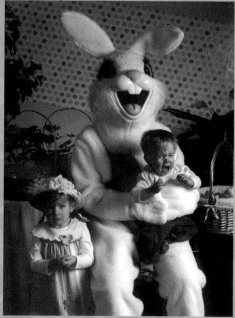

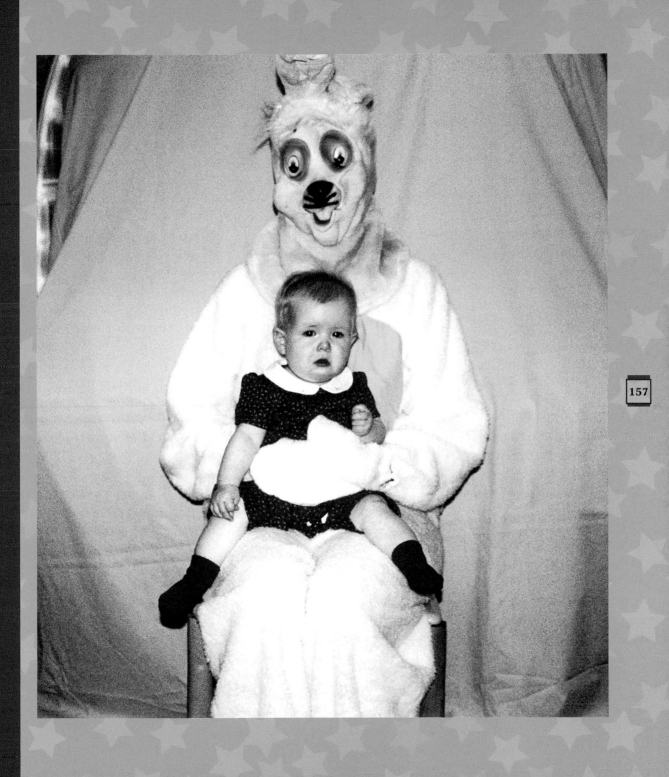

THE BAG-O-LANTERNS

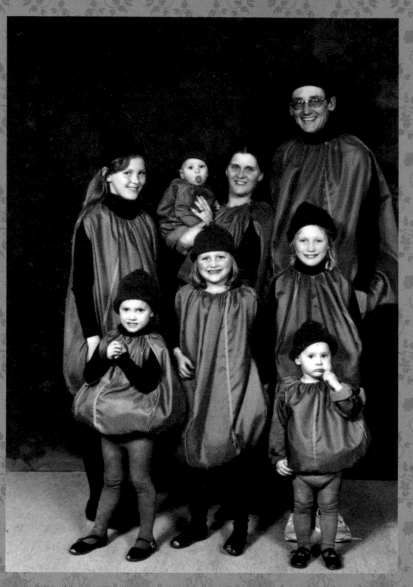

Dad was determined not to get egged this year.

OLD SMOKEY

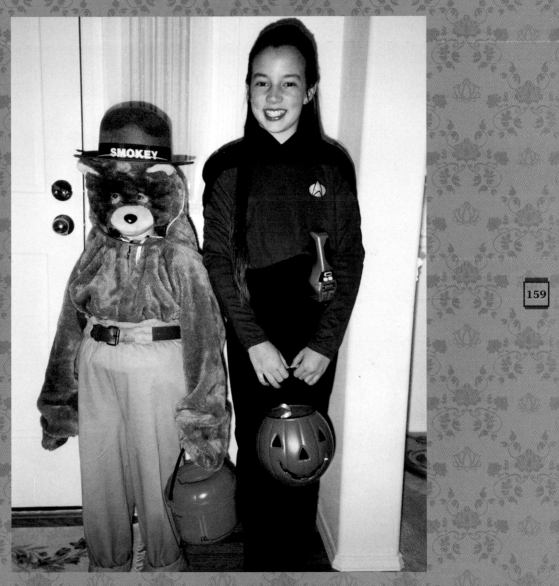

This young lady was the only elderly Smokey the Bear in the neighborhood.

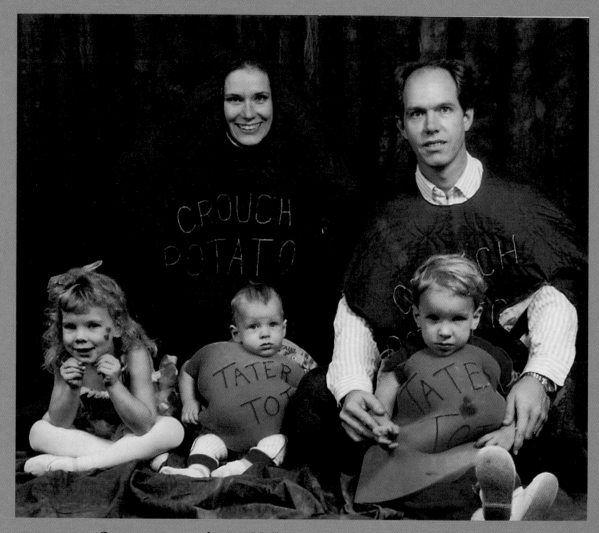

Sometimes we forget Halloween is about the children.

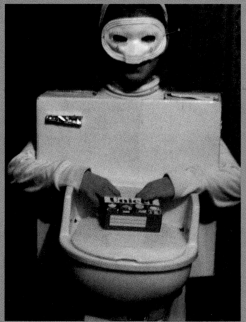

HOMEMADE

The coolest costumes aren't always store-bought.

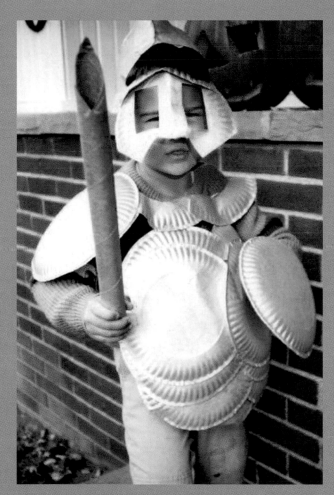

Don't hate him because he's a beautiful baster.

FOWL PLAY

Hasn't the turkey suffered enough humiliation?

CHRISTMAS STORY

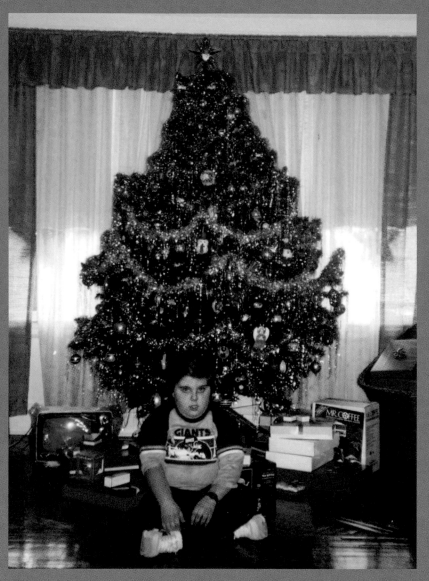

This is what happens when you wait all year for a freaking
Mr. Coffee.

BAD SANTA

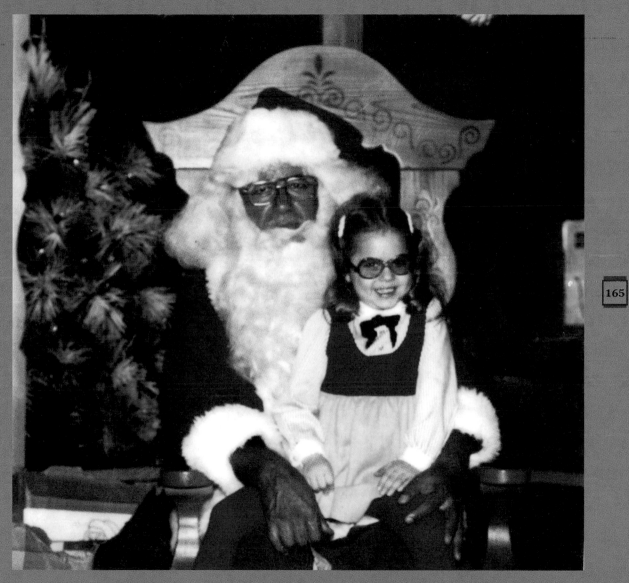

He just got a lot more real.

THE DRIBBLER

A reminder to us all to shake responsibly this holiday season.

SKETCHY

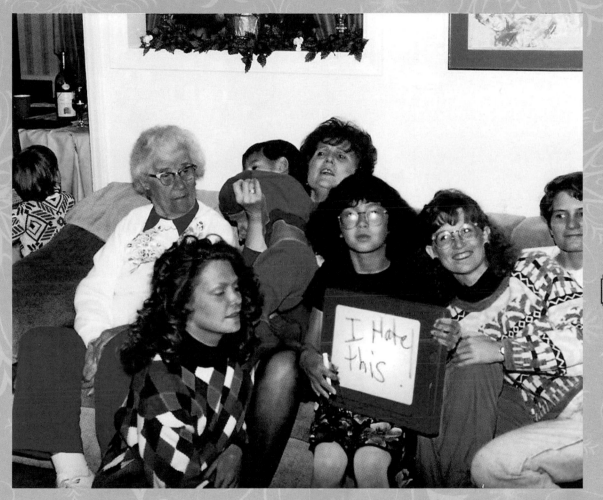

This young lady took some creative license with her drawing of a snowman.

BEHIND THE
AWKWARDNESS

Me (left) and my sister, dressed up as doilies for Easter. We have naturally *very* straight hair and these perms were a disaster.

Dorothy and Nancy
Atlanta, Georgia

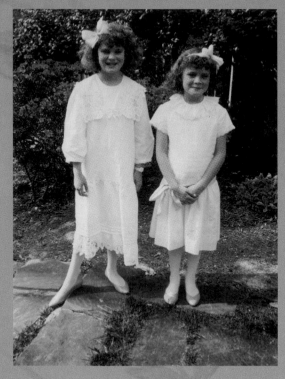

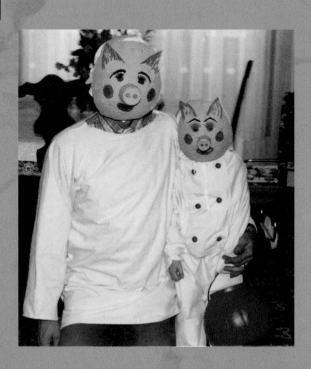

My dad made the costumes that year, and he felt pretty confident in his abilities. He just laid me out on the ground and traced around me, then cut out the fabric and sewed it together. Unfortunately, he'd neglected to consider how I'd go about lifting my arms.

Shannon
Calgary, Canada

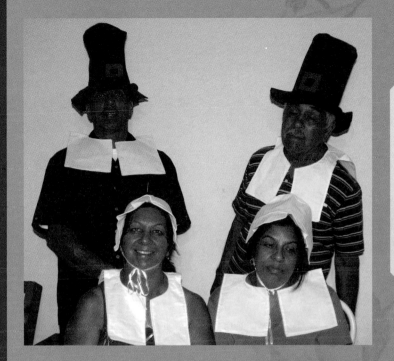

It was my mom's idea for everyone to dress up. We all protested, which is why it looks like we've thrown back a few.

Oscar
San Pedro, California

My grandma is notorious for giving bad gifts.

Courtney
Superior, Wisconsin

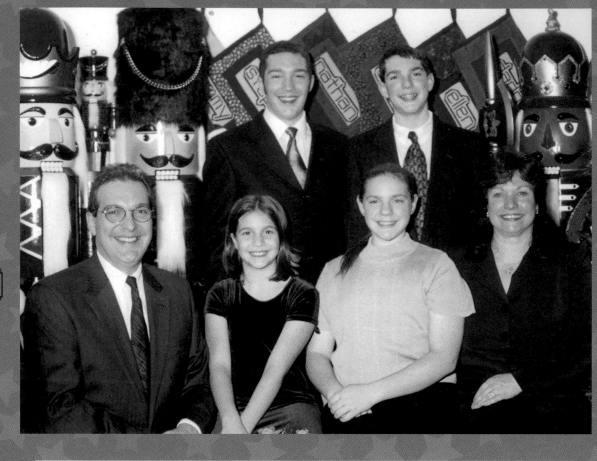

My dad thought it would be fun to collect giant nutcrackers. So, for three years in a row, he bought a six-foot nutcracker from Costco.

The Daniels Family
Bloomfield Hills, Michigan

GIFT WRAPPED

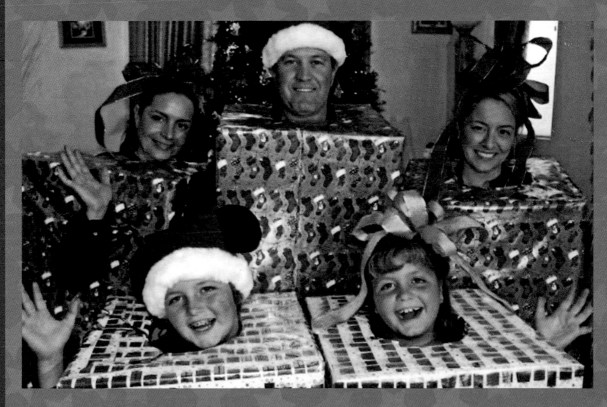

Give the re-gift of family.

CRACK OF DAWN

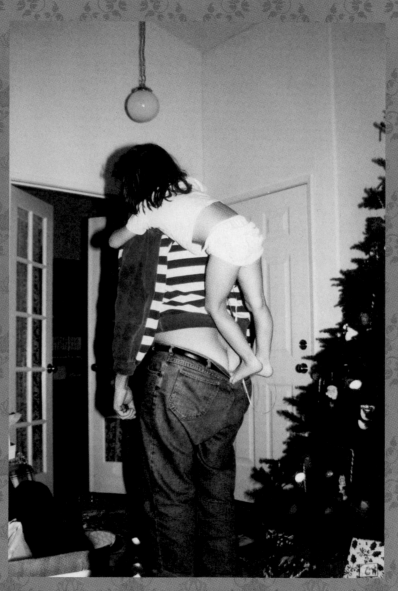

When Bethany woke up, she didn't expect to see a full moon.

FESTIVAL OF LIGHTS

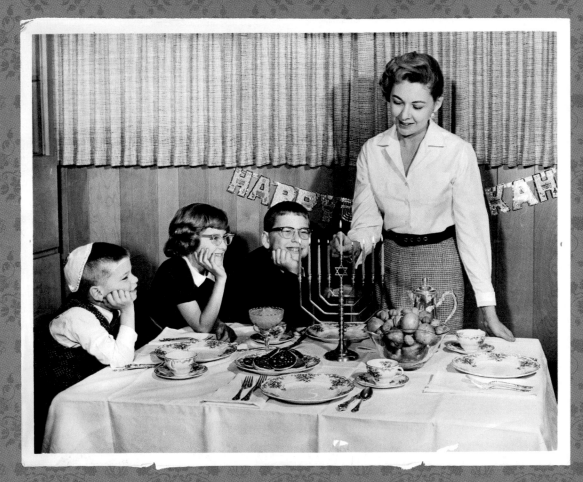

Eat your heart out, Christmas tree.

AWKWARD HOLIDAY STORIES

As a kid, I took Halloween very seriously. Every year, I would return from a long night of trick-or-treating and immediately begin itemizing my loot by putting them into different shoeboxes labeled with the name of the candy. And every year, my father would find the box labeled "Milky Way" and clean me out when I wasn't standing guard. One Halloween, I decided to get smart and I labeled the Milky Way box "Mike and Ike," knowing that he hated Mike and Ikes. I came home from school the next day to find Dad with his hand in the Mike and Ike box and caramel and nougat all over his face. So much for my genius plan.

Garrett
Florham Park, New Jersey

My family has a tradition of everyone going around the Thanksgiving dinner table and saying what we're thankful for. Usually, we talk about being thankful for our good health or something positive that might have happened that year, etc. But when it got to my precocious seven-year-old cousin, he stood up and announced that he wanted to thank the sperm he was conceived with for "coming in first."

Gabe
Madison, Wisconsin

Thanksgiving 1996 was unusual, as my grandparents had both of their sons, both of their daughters-in-law, and all three of their granddaughters there. I was there with my husband. And my great-aunt Clara, my grandfather's sister, was also attending. Clara, aged eighty-four, was the oldest of seven siblings. My uncle leaned over and said, "So, Clara. Do you have any memories of seven kids around the Thanksgiving table?" Aunt Clara replied, "Well, I'll tell you about one Thanksgiving. I'd invited our brother Bob to come eat at my house. He didn't come over, so I told my son to go over to his trailer because I knew something was wrong. And when he got there, Bob was sitting on the couch, dead."

Amanda
Austin, Texas

About two years ago at Christmas, my aunt brought her new albino boyfriend home to meet the family. We decided to take a family photo with my little cousin's Polaroid camera. Usually in the family of dark-skinned Italians, I'm the one who tends to stand out, since I have a lighter complexion. When the picture developed, we all hovered over to look and I said, "Let's try to find the white face this year!" My mother then elbowed me and, realizing what I just said, I hung my head in shame.

Stephanie
Trenton, New Jersey

My family has learned not to expect much from my grandparents in terms of presents. One year, our family got an expired "gourmet" beefstick-and-cheese assortment. Another year, I unwrapped one gift to receive a keychain that my siblings and I instantly recognized as a McDonald's Happy Meal toy; it was one that I had previously gotten during a visit to my grandparents and left at their house. Thanks for the regift.

Caroline
Greenwich, Connecticut

My dad's mother, whom we called Meemaw, was the kind of old lady who enjoyed being able to say whatever the hell she was thinking. When I was a sophomore in college, my roommates and I, while traveling on spring break from our tiny one-stoplight town to LA, decided to go to Glamour Shots. My mother was so enamored of the resulting shots that she framed the eleven-by-fifteen for Meemaw's "big" Christmas gift. My mother had endured Meemaw's salty opinions of *every* Christmas gift she'd ever received, even from my two sisters and me as children, for thirty years—but this year Mom *knew* she had a winner. Christmas Day, Meemaw opened the box, lifted the tissue paper, and said, "I don't want that. It doesn't look anything like her."

Meredith
San Diego, California

My British parents used to host an annual Boxing Day party here in Texas. It was a large open house–style party and very popular. Boxing Day in the UK is the day after Christmas. My father had gotten a purple martin condo (very tall, elaborate birdhouse) for Christmas, and he was so excited that he wanted to put it up right away to have it ready for the purple martin nesting season in the spring. While my mother took care of the guests at the party, he worked on getting the martin house and its pulley system working—it required hoisting with a rope far up into the air to sit high on a post. Before the final step in setting up the bird condo, he came into the house, walked into the living room, and announced very loudly to the large group of guests gathered there, "Who wants to see an erection?"

Amanda
Austin, Texas

One year, my family was hosting Christmas and we had a ton of relatives coming over for dinner. My brother and I were both in college and completely broke. We didn't have enough money to buy anyone presents, so we decided to rummage through the house a few hours before dinner for gag gifts.

During dinner, my brother and I give out our gag gifts. We're all having a good laugh when my mom says, "Oh, wait, there's one more for me!" I'm looking at the gift and thinking, "I don't remember wrapping anything for Mom." She unwraps the present, holds up a Lucite framed Nativity scene, and says, "Oh my God! This is hilarious! How gaudy!" And just as we're all about to join her in laughter, my sister's new boyfriend, Andrew, pipes up for the first time and says, "Actually, that's from me."

Ivana
San Francisco, California

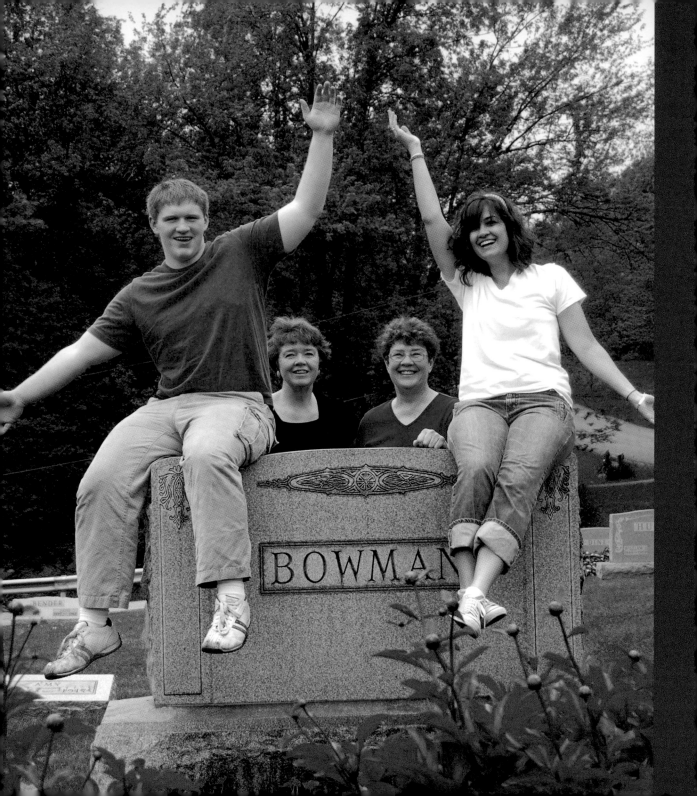

13

Strange, Not Awkward

Of the thousands of awkward photos we've received, there were a few that were, well, a little different. They often left us confused, sometimes scared, and always wondering what the hell was going on. At first, we didn't know what to do with them, so we filed them away. But that didn't last for long, because we couldn't stop thinking about them. So we took a second look and ultimately realized that oddness was also something worth celebrating.

IT'S NOT EASY BEING GREEN

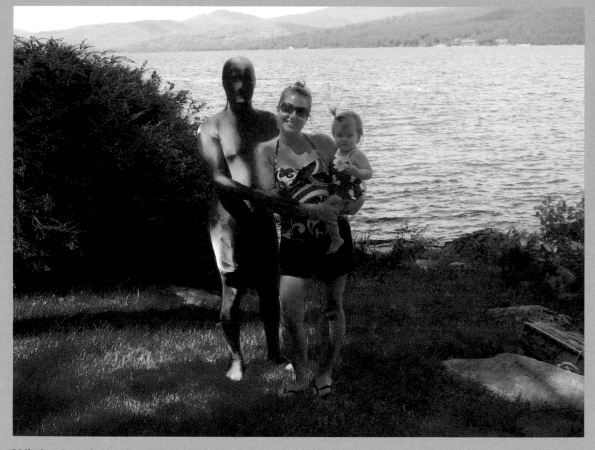

While this dad was trying to teach his daughter a valuable lesson, this actually does nothing for the environment.

HEAD OF THE FAMILY

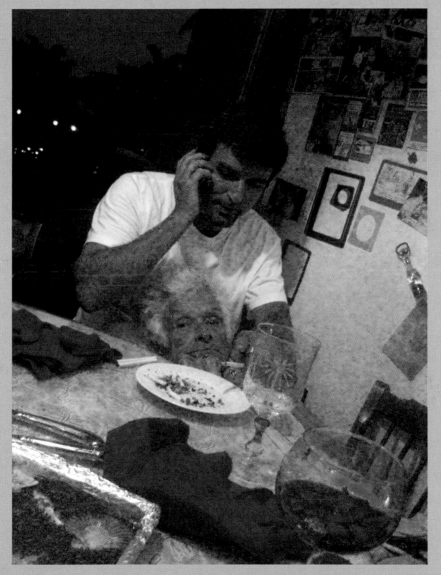

Never ash on Grandma.

CONCERTO NO. 2

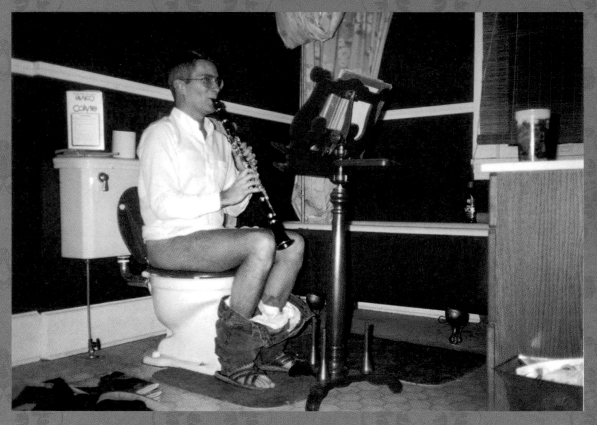

Some people run the sink. This gentleman responds to Tchaikovsky.

HAY SEASON IN LATVIA

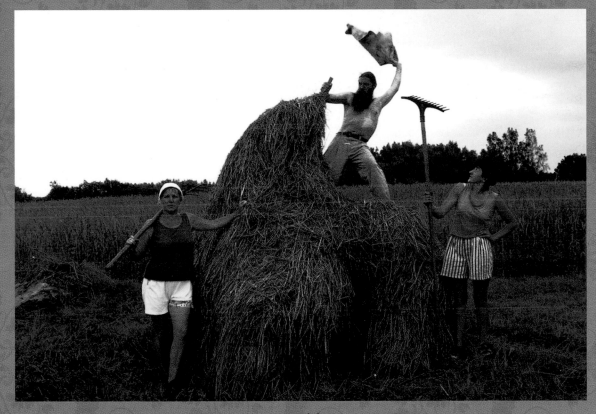

A very rare case of farmer's ax tan.

GRRR

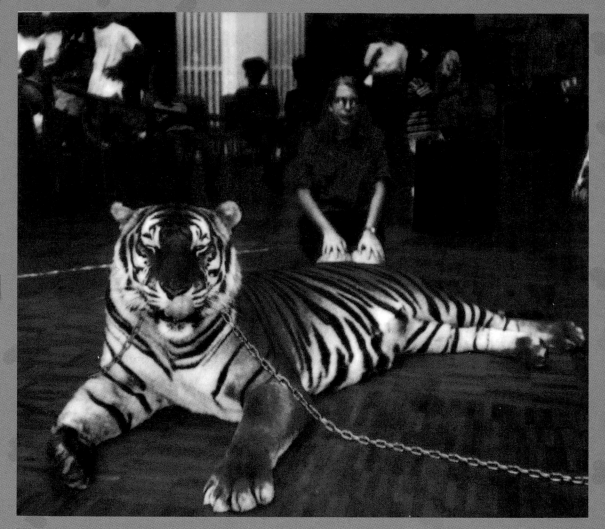

We think Amanda summed it up best: "This is me. And a tiger. In a shopping mall."

Has anybody seen Aunt Telcia?

Conclusion

I magine if family were perfect. Our parents would be cool, reasonable, and incapable of saying anything that might embarrass us. Our siblings would be our biggest fans, let us control the remote, and always give us first dibs on everything. Our grandparents would sit away from the steering wheel, eat dinner at night, and wear sunglasses that actually fit the shape of their faces. Our cousins would be instant best friends. Our relatives would wear name tags and never have too much to drink. There would never be another awkward silence, awkward conversation, or awkward moment. Well, we must ask ourselves . . . is that what we really want?

Yes, probably. But let's face it—that's never going to happen! So we have no choice but to embrace it, and once we do, we might come to realize that the family that makes us so unbearably uncomfortable is also the same family that makes us laugh, makes us proud, and makes us feel loved. And that's something we can all take comfort in.

Contributors

Page 10: The Hanscom Family, Anchorage, AK; page 12: The Long Family, Bloomington, IN; page 13: Barbara Cox, Raymond, MS; page 14: Nathan Cookson; page 15: The Beggs Family, Kansas City, MO; page 16: JennyAnn Wheeler, Olympia, WA; page 20: Yuriko Lawson; page 21: The Ryan Family, Renton, WA; page 22: The Robbins Family, Indianapolis, IN; page 23: John Kolic, Phoenix, AZ; page 24: The Lehndorff Family, Fitchburg, MA; page 25: The Smith Family, Miami, FL; page 26: Nathaniel FitzGerald, South Bend, IN (top), and The Hackbarth Family, Appleton, WI (bottom); page 27: The Sparks Family, Laguna Beach, CA (top), and The Flanery Family (bottom); page 28: Mark Bonfield, Castle Vale, UK; page 29: The Wiggs Family, Indianapolis, IN; page 30: Brenda Quinn (top right), Brigette Krupitzer Dineen (bottom right), and Kelly, MI (left); page 31: The Laurtich Family; page 32: The McDougal Family, Charleston, WV (top right), Charleen Barker, Columbia, SC (center right), Wil Foster, Indianapolis, IN (bottom right), The Templeton Family, Pink, OK (left); page 33: The Binion Family, Houston, TX; page 36: The Treppin Family, Long Island, NY; page 37: Allison and Wendy Green, Davenport, IA; page 38: Chris and Emmy Bender, Los Angeles, CA; page 39: Kristin Sullivan, Cudahy, WI; page 40: Claire Parkinson; page 42: Shelita Thomas; page 43: Fran & Kristi, Upland, CA; page 44: Sarah Jazuk, Vallejo, CA; page 45: Julie Ziesemann (Sungazing Photography), St. Louis, MO; page 46: Becky Remiger (bottom); page 47: Kristin Schields, Baltimore, MD (top left), Jessica Buchikos, Ocean Springs, MS (top right), The Brooks Family, Midland, TX (bottom); page 48: Peter DeLorenzo, Glen Cove, NY; page 50: Sydney Broere, Bracebridge, ON (top left), Jennifer McKeever, Blairstown, NJ (bottom left), The Boysen Family, Winona, MN (bottom right); page 52: The Topper Family, San Francisco, CA; page 53: Melissa Wygand, Wantagh, NY; page 54: Samantha Copping, St. Charles, IL (top right), The Angle Family, LaPlata, MD (left), The Andres-Gleave Family, Colville, WA (bottom right); page 55: V. A. Davis, Lexington, KY; page 56, left to right: S. Marcus Hswe; Amanda Bowman, Southgate, MI; "Chub," Charleston, SC; Lizz Koch, Corvallis, OR ; page 57, top row, left to right: Amanda Browning, Flemington, NJ; Sarah; The Stefani Family, Lincoln, CA; Robert and Amy Ekis; page 57, center row: Kelly Stevenson (reigning queen of the PERMullet), Madison, WI; Sarah; Betsy Lash; Robert Elwell, Schenectady, NY; page 57, bottom row, left to right: Emily Garrett, Columbus, OH; Laura Napolitano, Orlando, FL; Sarah Gomez, Corpus Christi, TX; Gina and Matt Stack; page 58: Greg, Chevy Chase, MD; page 59: Speedy Mercer; page 63: B.J. Clark, Dallas, TX; page 64: Kevin, Kelly, and Nate Kemp; page 66: Tadje Family; page 67: Andew Dugstad; page 68: Nathaniel FitzGerald, South Bend, IN; page 69: Jeffrey Buck, Baton Rouge, LA; page 70: Madeline Horan, Gaithersburg, MD (top right), Leeandra Nolting (bottom right), Camarena, NY (bottom left); page 71: The Preston Family, Fort Collins, CO; page 72: Joseph Ortega Flores, Manila, Philippines; page 73: The Myers Family; page 78: The Pittenger Family, Fort Wayne, IN; page 80: The Caramin Family; page 81: Taylin Wilson Mississauga Ontario; page 82: Darcy Wheeler, Austin, TX (top right), Kelsey Haugen, Corona, CA (bottom right), Missie Johnson (left); page 83: Kimberly and Virginia (aka MaMa); page 84: Paul (top right),

Nicky Parttridge and Grandma Shirley (bottom right), Lisa Theis, Issaquah, WA (left); page 85: Chris Dillard; page 86: Kenny and Selma Furst; page 88: Cathy Carrel; page 91: Aunt Mary Morris, The Chappell Family, Charlotte, NC; page 92 (left): The Kinser Family, West Virginia and Chicago, IL; page 93: Allison Peret, Milwaukee, WI; page 94: Christine Dufour; page 95: Grant Parker, Hogan McHugh, Kaitlyn Nugent, and Breland Brum; page 96: The Jones Family, Lake Oswego, OR; page 98: Karen Wagner, Dawn Wagner, Jim Wagner, and Deb Wagner Avery; page 99: Thea, Rachel, and Laurel; page 100: The Hoke Family, Omaha, NE (bottom right), Gary Angle and Bubba Richardson, TX (left); page 101: Joey, Bogey, and Divot; page 102: Megan Wallace and Jillian Zavitz (dog: Miss Muffet); page 103: Katy Rivlin and Ari Glogower, Jackson, MS (top right), Ernest C. Smith III and Mary E. Brooks, Douglasville, GA (center right), The Shields Family, Bellingham, WA (bottom right), Leslie Jones, Kansas City, MO (left); page 104: The Hart Family, Logan, UT; page 106: The Stierch-Denton Family, Indianapolis, IN; page 107: The Williams Family, Moreno Valley, CA; page 108: Alyssa Erikson, Castro Valley, CA; page 109: Justin Morse (top right); page 110: The DuBois Family; page 111: The Schmidhuber-Geulen Family, Munich, Germany; page 112: The Busch Family; page 113: The Bender Family; page 114: The Bohnet Family (top left), The Shields Family, Cody, WY (bottom left), The Diamos Family (right); page 115: The Wright Family, Dallas, TX; page 117: Tom, New York, NY; page 120: The Speice Family; page 124: Megan Scherer; page 126: The Coffey Family, Spokane, WA; page 127: The Berar Family, Saskatchewan; page 130: The Mullin Family, Auburn, CA; page 131: Kristen Brooks, Kathy Prasad, and my mom, Dorothy Tompkins (top right), LeAnn Baker (left); page 134: CJ, Gainesville, FL; page 135: A.B.; page 136: Nora Krinitsky (bottom right), Erin Benkoil and her family (left); page 137: Molly Thrailkill; page 140: The Davis and Brian Families; page 142: Samantha Villenave, Cruas, France; page 143: Ginger & Heather, Brooklyn, NY; page 144: Sean Norton (left), Jessica and Tom Guffey, Lindale, TX (top right), Colleen O'Connor Toberman, Minneapolis, MN (bottom right); page 145: Amanda Reid, Seattle, WA; page 146: Sean Montgomery; page 147: The Kozaks and their "close" friend Heidi, Chicago, IL; page 149: Lisa Theis, Issaquah, Washington; page 150: Amanda Reeves; page 151: Adam Theroux, Providence, RI; page 152: The MacIsaac Family; page 154: The Dicksons; page 156: The Cahn Boys, Long Beach, CA (top right), The Spencer Family, Reno, NV (bottom right), Chris and Kristi Bender, Los Angeles, CA (left); page 157: Kristie Escoe, Oklahoma City, OK; page 158: The King Family, Alberta, Canada; page 159: The McCampbell sisters; page 160: Crouch Potatoes; page 161: Ariel and Noah Alexander, St. Louis, MO (top left), The Smith Family (bottom left); page 162: Eric Billings, photo taken by Kellie Clover; page 163: The Powell Family, Westborough, MA; page 164: Joseph Moriarty, Long Island, NY; page 165: Trisha L.; page 166: "The Dribbler" Jim Hasson; page 167: Melody Woods, Gheri Woods, Lou Woods, Tracy Woods, Jessie Woods, Lindsay Hall , Alex Hall, and Malloree Hall; page 168: Santa's Awkward Surprise, Chula Vista, CA; page 172: Bethany; page 173: Joel Gallen; page 178: Maryam Riazian, Akron, OH; page 180: The Kaminski Family, Milford, CT; page 181: The Sloan Family; page 182: Peter Wright, Jacksonville, FL; page 183: Šlosbergu ģimene, Bauska, Latvia; page 184: Amanda Price, Brooklyn, NY; page 185: The Flesher Family; page 186, in alphabetical order: Kerry Auld; Beerley Family, Texarkana, TX; Bennett Family, Yonkers, NY; Caitlin Bennett; Boyer Family, Lebanon, PA; Dean Browell, Richmond, VA; Gina Brower, Philadelphia, PA; Carly; Chandler Family, Coos Bay, OR; Compton Family; Corvetti Family; Cotton Family, Atlanta, GA; Lisa Curtis and parents; Chloe D., Norwell, MA; Effendi and Zach; Emily; Elizabeth Esry; Fairchild Family, Provo, UT; Joel Frozena, Berkeley, CA; Joel Gallen; Bob Gorum; Sarah Gran, Connecticut; Lora Gress; Haas Family, Indianapolis, IN; Linda Hartman; Ryan Hebert, Alpharetta, GA; Alex Henley; Hickey Sisters, Naperville, IL; Eric Isaac; Jennifer and Great Uncle Mike; Jordan Family; Nate Kinney, Phoenix, AZ; Etti Kirshner and Sheldon; Kristi, Upland, CA; Kristy M. Leritz, Stillwater, MN; Livingston Family, Norman, OK; Alexandra Lubman, New York, NY; Lucien Murat, Garches, France; David Maina; Michelle, Modesto, CA; Hazel Nicholson; Brian and Terri Ann Nuckolls; Bernadette Ojenda; Pepin Family; Perry Sisters, Flower Mound, TX; Courtney Podvin; Rosie Pooley and Tom Norman, Rug, England; Reed Family, Newton, MA; Stephanie Rines; Jeff S.; Simmons Family, Clinton, IA; Simonson Family, Rosholt, SD; Dan Smith; Jessica Sorenson (photographer), Stacey Stephens, and Jake Morrison; Adam Stark, Des Moines, IA, via Muscatine, IA; Laura Starnes; Straw Family, Salt Lake City, UT; Beckie Szmania, Milwaukee, WI; Taylor Family; Tiffany; Toney Family, Canton, GA; Trotter Family, Atlanta, GA; Courtney Underwood; Webb Family/Missy Webb; Carson Webb, Lafayette, LA; Eric Webber, Austin, TX; Bodnar Wernimont, Alice, Saint Paul, MN; Wesenberg Family, Sylvania, OH; Whitt Family, Cincinnati, OH; Wright Family, Waterloo, ON; Nelson, Abby, and Stacy, Terry, and Joy Zubkousky

Acknowledgments

WE WOULD LIKE TO THANK: All of the awkward families who have contributed to our website—you are the heart and soul of AFP, and without you, none of this would be possible; Kevin Mulhern and radio station 94 WHJY in Providence, Rhode Island— you spread the word and we are forever grateful; Mickey Worsnup, for generously giving his time to help build the site; the Hanscom family, for being the first ones brave enough to send in their family photo; the AFP team—Ivana Ma, for always making us sound like we know what we're doing, and Blaire Bercy, for all her hard work and for the soothing sound of her *Charlie's Angels* ring tone; Ryan D'Agostino, for giving us support when we desperately needed it; Justin Laub, for all of his guidance and advice; Sante La Brea restaurant, our surrogate office, for not closing on us the many late nights we spent there; our agents, Rebecca Oliver and Adrianna Alberghetti at WME; our lawyers, Allison Binder and Rick Genow; our awkward manager, Charlie Gogolak at Benderspink; JC Spink; everyone at Three Rivers Press, including Philip Patrick, Campbell Wharton, Dyana Messina, Jay Sones, Maria Elias, and Emily Timberlake; and finally, our amazing editor, Suzanne (aka Susan) O'Neill. We appreciate all of her patience with our neuroses and for believing in this idea from the beginning.

MIKE BENDER WOULD LIKE TO THANK: My parents, Jules and Rebecca Bender, for their love, support, and putting up the ski photo that started it all; Chris and Kristi Bender, for always being such good sports; Fran Dyer; my nieces, Emmy and Selma, for being my best audience; my grandparents Selma and Kenny Furst, the funniest people I know, for their inspiration; Aunt Simone, for always being supportive of everything I do; Matt Bijur, for being a great friend and trusted advisor on the site; Tim Loree, for being there from the SAC days; SuChin Pak, for all of her encouragement and enthusiasm despite having to hear about this book every day; all of my friends who trusted me enough to share their awkwardness: Mia Kirshner, Karen Lutz, Jay Karas, Andrew Gurland, and Joel Gallen; China Chow, for always laughing; Din-Din; to all the English teachers who ever marked up my papers with red ink; Richard Brener, for giving me my first break; and finally to failing miserably at the sport of tennis. If it wasn't for that, I would have never had the motivation to start writing.

DOUG CHERNACK WOULD LIKE TO THANK: My wife, Amy, for her love, encouragement, and understanding that finding a photo of O.J. Simpson crashing a family reunion was a reasonable excuse to cancel dinner plans; my lucky charm, Ravi (born a week before AFP), whose screams in the middle of the night inspired me during those first crazy weeks; my parents, for their love, support, and getting the word out about the site to the entire Tri-State area; my brother, Greg, for having a great sense of humor about himself; my good friends Ben Padnos and Keith Richman, for teaching me how to use the Internet, seriously; and to Mark Bomback, for his contribution to the book and all of his help over the years.

About the Authors

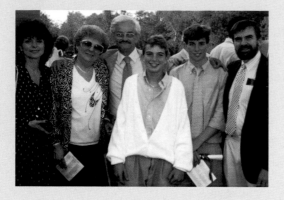

MIKE BENDER is a screenwriter whose credits include *Not Another Teen Movie* and the MTV Movie Awards. He had to fish himself out of that white cardigan.

DOUG CHERNACK has created and produced television shows for E, Fox Sports, and The Golf Channel. He is still a sucker for gold jewelry and short shorts.